The Birth of Photography

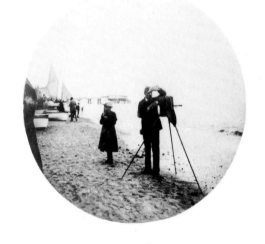

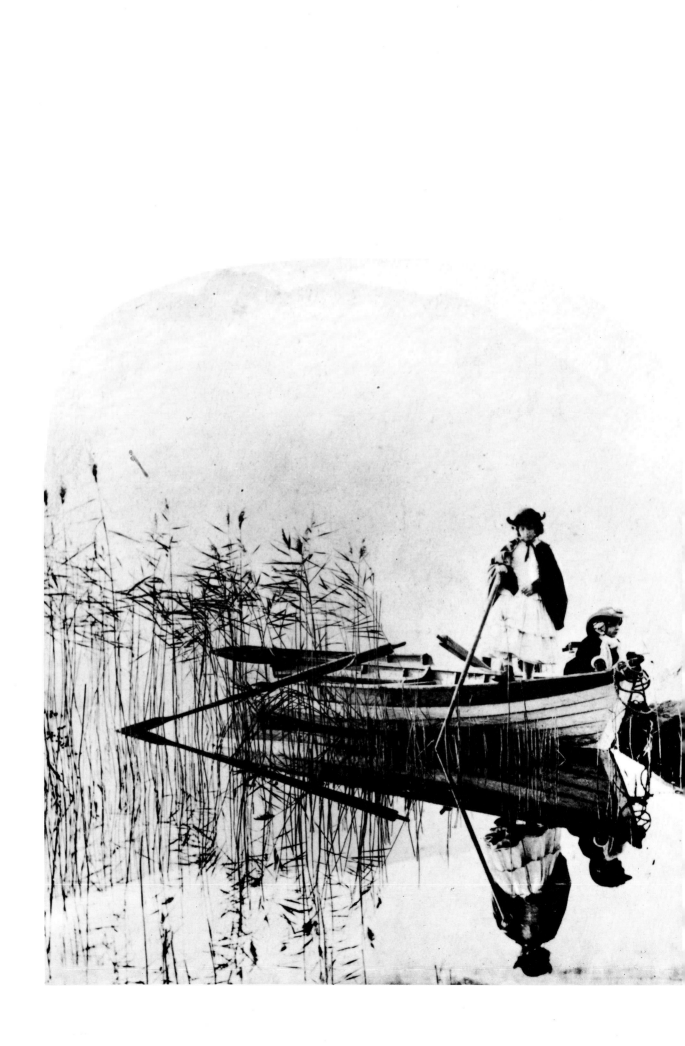

The Birth of Photography

The story of the formative years
1800–1900
by
BRIAN COE
Curator, Royal Photographic Society
Former Curator of the Kodak Museum

**SPRING
BOOKS**

First published in Great Britain in 1976 by
Ash & Grant Limited

This edition published in 1989 by Spring Books
An imprint of Octopus Publishing Group PLC
Michelin House
81 Fulham Road
London SW3 6RB

IBSN 0 600 56296 4

Produced by Mandarin Offset
Printed in Shekou, China

Contents

Introduction

Today there is virtually no area of human activity in which photography does not play some part. Every year millions of photographic images are made, not only by amateur photographers but also by photographers in industry, science, commerce, entertainment, medicine, publishing and many other fields. This process, so familiar a part of modern life, evolved throughout the last century, from the first tentative experiments around 1800 to the popularization of photography introduced with the Brownie camera in 1900. This book describes how photography began and illustrates the work of some of the pioneer photographers.

The reader who wishes to become more familiar with Victorian photography is advised not only to refer to the growing literature on the subject but also to visit museums in which original equipment and photographs can be seen. No book illustrations can do justice to the beauty of some of the early photographic processes.

Some museums displaying aspects of the history of photography are : in England – The Science Museum, London, The National Museum of Photography, Film and Television, incorporating the Kodak Museum, Bradford, The Royal Photographic Society, Bath, The Oxford Museum of the History of Science, The Northwestern Museum of Science and Technology, Manchester, The Fox Talbot Museum, Lacock, The Barnes Museum of Cinematography, St Ives, Cornwall; in Scotland – The Royal Scottish Museum, Edinburgh; in the United States of America – The International Museum of Photography at George Eastman House, Rochester, NY, The Smithsonian Institution, Washington, DC; in Germany – The Deutsches Museum, Munich, The Stadt Museum, Munich, The Agfa-Gevaert Museum, Leerkusen; in Belgium – The Sterksho Museum, Antwerp; in France – Arts et Métiers Museum, Paris; and in Czechoslovakia – The Museum of Technology, Prague.

Picture credits
The Science Museum, London 22, 24 (top), 25 (above), 27, 68 (bottom), 93 (above)
National Portrait Gallery, London 69 (top right, bottom)
Fox Talbot Museum, Lacock 23, 68 (top left)
Library of Congress, Washington, DC 66 (bottom right), 83 (above)
Howarth-Loomes Collection 33 (above left), 90 (right)
Josiah Wedgwood & Sons Ltd 13 (right)
Smithsonian Institution, Washington, DC 64 (bottom right)
Victoria & Albert Museum, London 88 (centre left)
International Museum of Photography at George Eastman House 89 (above)
Kodak-Pathé Collection, Vincennes 108 (top left)
The Webb Collection 111
The Schultze Collection 85
The Marquis of Tavistock and the Trustees of the Bedford Estate 54 (far left)
Mr A. H. Stanton 8
The remainder are from the Kodak Museum collection.

I am indebted to my former colleagues in the Kodak Museum, Mrs Christine Lucas, assistant curator, and Mr Peter O'Connor, photographer, for their help in the selection and preparation of the illustrations. I would like to thank Mr

Bernard Howarth-Loomes, Mr Harold White and Mr Stephen Croad for their helpful advice and information.

Notes
Although popularly called 'Fox Talbot', William Henry Fox Talbot's own preferred usage and customary form of autograph was 'Henry Talbot'. He is also known to have expressed a positive dislike for his mother's habitually addressing him as 'Fox Talbot', 'Fox' being only one of his three christian names and not hyphenated with his surname. For these reasons, the name, 'Talbot', rather than 'Fox Talbot', has been used throughout the text.

Prices are quoted throughout in 19th-century values (decimal equivalents: one shilling = 5p; one guinea = £1.05). Owing to inflationary trends and fluctuating exchange rates, conversions into modern equivalents are often misleading and ephemeral. The reader is perhaps best advised to consider that in the late 19th century a day's wage for an unskilled employee was about one shilling, while a skilled chief operator in a London photographic studio might have received 10 shillings a day.

Brian Coe

7

1 The birth of photography

Miniature painting, self portrait by Henry Collen, 1825

Since prehistoric times man has been making images of himself and the world around him but until comparatively recently the processes involved have required skills possessed by few. The growth of portrait painting in Europe from the time of the Renaissance was restricted by the limited number of patrons wealthy enough to commission major works. During the 18th century a growing middle class created a demand for less expensive methods of preserving likenesses of themselves. In part, this demand was satisfied by miniature painters, whose work was suited in both scale and cost to the smaller home. However, it was the silhouette that first satisfied a mass demand. The profile pictures, traced from the shadow cast by a lamp or cut freehand from black paper, first became popular in the early 18th century. They were named after Étienne de Silhouette, a French finance minister and amateur profile maker, whose pennypinching policies made his name a byword for cheapness. The black outline picture, often embellished with gold paint, glazed and hung in a suitable frame, graced the walls of even the most humble homes by the beginning of the last century.

Although the silhouette was relatively inexpensive (typically a scissor-cut profile cost about two shillings in 1800), each one had to be drawn or cut individually. Copies took as long to make and so cost as much as the original. The first system producing multiple copies of a portrait was invented by Gilles Louis Chrétien in 1786. In his apparatus a profile cast by a lamp onto a glass plate was traced by an operator using a pointer connected, by a system of levers like a pantograph, to an engraving tool moving over a copper plate. The finished engraved

plate, with added details of features and costume, could be inked and printed many times. Chrétien called his device the Physionotrace. These mechanical methods of making images were cheap, but could not rival the much more costly and skilled art of miniature painting, the products of which were full of detail and colour. Inventors and artists began to speculate: could light be made to act directly to produce a picture, cheaply and without special skills? To make such a picture, two fundamental requirements must be met. First, a suitable optical device must produce an image. Secondly, a surface capable of permanent alteration on exposure to light must be prepared to receive it.

Both these principles had been established by the beginning of the last century. If a small hole is made in the wall of a darkened room, perhaps through the closed shutters of a window, an image of the outside world will be produced on the opposite wall. The image will be inverted and dim; if the hole is enlarged there will be a brighter but less well-defined image. The phenomenon of the camera obscura (literally, a dark room) had been observed in ancient times. Chinese scholars in the 4th century BC were probably familiar with the effect. Certainly the Arabian scholar Alhazen described the effect in the 10th century AD, observing its usefulness for viewing solar eclipses without risk to the eyes. A very clear description was given by Leonardo da Vinci in his notebooks: "When the images of illuminated objects pass through a small round hole into a very dark room . . . you will see on the paper all those objects in their natural shapes and colours. They will be reduced in size, and upside down, owing to the intersection of the rays at the aperture". Clearly this was a useful effect for the artist and the camera obscura was recommended by Giovanni Battista della Porta in 1558 in his book *Natural Magic*. He suggested that a brighter and clearer image could be produced by replacing the small hole with a convex lens or concave mirror. He also proposed that an optical system could be used to transmit from room to darkened room the images of actors for entertainment. During the following 300 years the camera obscura was a feature of many public and private buildings. Even today a few are still in operation and can be seen at several places in Great Britain, notably Edinburgh and Bristol.

To make the camera obscura practical for use by artists, versions were developed that could be carried from place to place like the sedan chair.

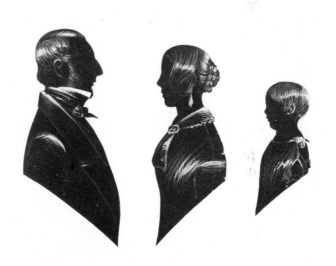

Top *Silhouette of a young man, c1790*

Above *Silhouettes of Mr and Mrs James Grey and Eleanor, c1840*

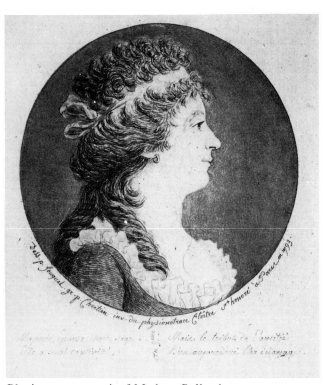

Physionotrace portrait of Madame Rolland, 1793

Even more convenient versions were made a collapsible tents with lenses and mirrors or prisms at the apex, displaying the image on a horizontal table surface. Portable forms were made from small wooden boxes with a moveable lens at the front, focusing an image on a ground-glass screen at the rear. An important 18th-century refinement introduced a mirror behind the lens to reflect the image onto a horizontal ground-glass screen in the top, usually screened by a hinged lid. This most popular form of camera obscura was widely used by artists who could copy or trace the image, simplifying the problems of accurately rendering form and, especially, perspective. It was this device that was to evolve into the photographic camera.

Natural philosophers have been aware since ancient times that light has an effect on certain materials. Some fade on exposure, others darken. The latter is especially true of certain compounds of silver. The first scientific study of this was carried out by J. H. Schulze in 1727. He filled a glass bottle with a suspension of chalk and silver in nitric acid and demonstrated that when exposed to light the mixture turned from white to a dark purple. By attaching stencils of black paper to the outside of the bottle he was able to print images of letters and shapes on the mixture, but they were destroyed when the liquid mixture was disturbed. In 1777 C. W. Scheele showed that this darkening of silver compounds by the action of light was due to the formation of metallic silver.

Around 1800 Thomas Wedgwood, son of Josiah Wedgwood, the potter, conducted the first experiments in making images on paper sensitized with silver salts. Perhaps as a result of working with his father's camera obscura, used in the design of decoration for pottery, Tom Wedgwood became fired with the idea of making the image record itself directly on paper. Aware of the published reports of Schulze and Scheele, he naturally turned to silver compounds. His experiments were described by his friend, the great chemist Humphry Davy, in a paper presented to the Royal Institution. Published in *The Journals of the Royal Institution*, No. 9, 22 June 1802, the paper was entitled 'An account of a method of copying paintings upon glass etc., invented by T. Wedgwood Esq., with observations by H. Davy'. This is how Wedgwood's experiments were described:

"White paper, or white leather, moistened with solution of nitrate of silver, undergoes no change when kept in a dark place; but, on being

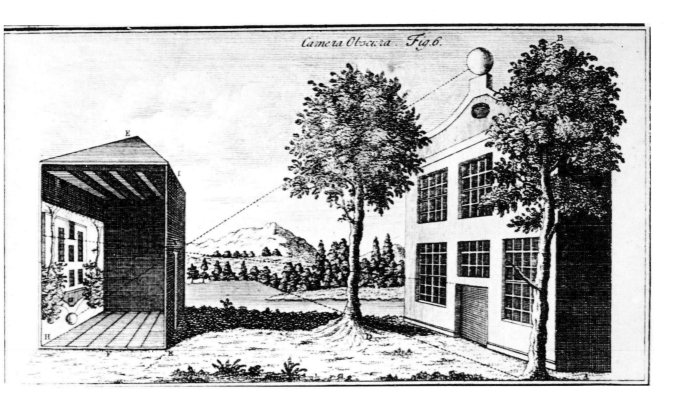

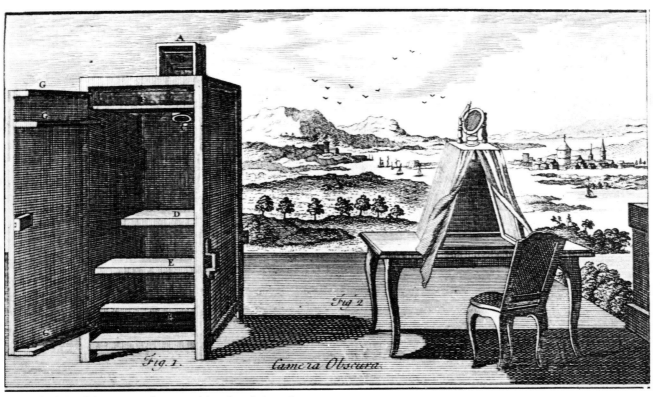

The principle of the camera obscura, with sedan chair and
tent models, from a treatise on optics, 1716

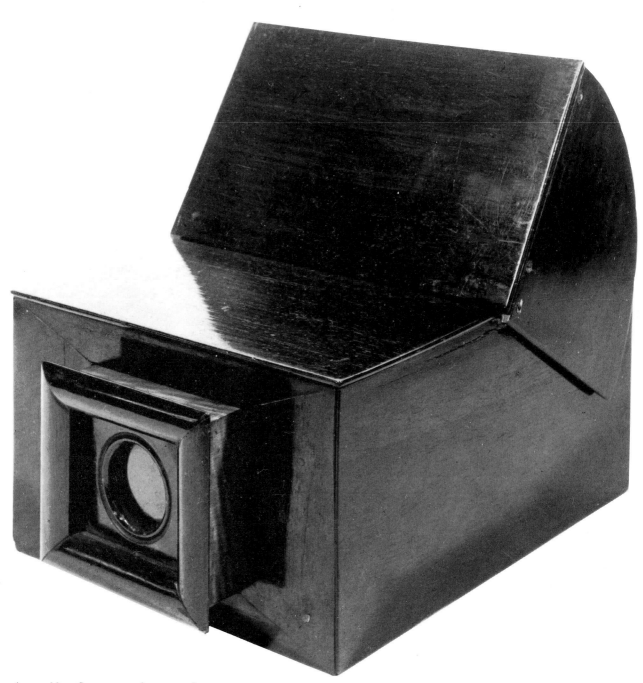

A portable reflex camera obscura, c1800

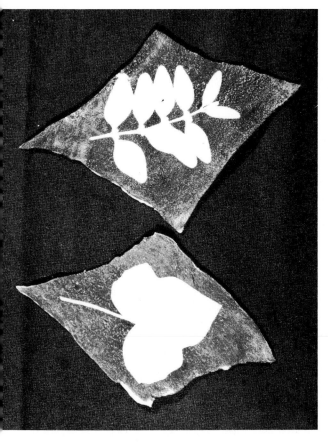

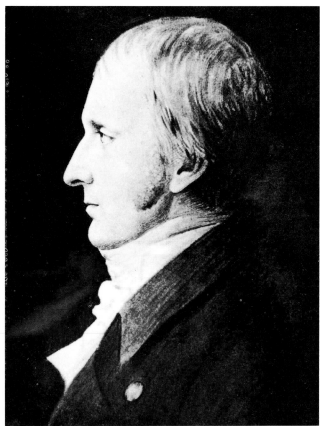

exposed to the day light, it speedily changes colour, and, after passing through different shades of grey and brown, becomes at length nearly black . . . outlines and shades of paintings on glass may be copied, or profiles of figures procured, by the agency of light. When a white surface, covered with solution of nitrate of silver, is placed behind a painting on glass exposed to the solar light, the rays transmitted through the differently painted surfaces produce distinct tints of brown or black, sensibly differing in intensity according to the shades of the picture, and where the light is unaltered, the colour of the nitrate becomes deepest.

" . . . After the colour has been once fixed upon the leather or paper, it cannot be removed by the application of water, or water and soap, and it is in a high degree permanent. The copy of a painting, or the profile, immediately after being taken, must be kept in an obscure place. It may indeed be examined in the shade but, in this case, the exposure should be only for a few minutes; by the light of candles or lamps, as commonly employed, it is not sensibly affected.

" . . . the images formed by means of a camera obscura, have been found to be too faint to produce, in any moderate time, an effect upon the nitrate of silver. To copy these images, was the first object of Mr. Wedgwood, in his researches on the subject . . . Nothing but a method of preventing the unshaded parts of the delineation from being coloured by exposure to the day is wanting, to render the process as useful as it is elegant."

It is surprising that Davy, a leading chemist of his day, could not suggest any chemical method of removing the unused silver salts so as to 'fix' the image. Certainly some materials existed at the time which would have given some permanence to the pictures. Wedgwood died soon after, in 1805, without developing the discovery that was so close to being a practical proposition. The first permanent images made directly by the action of light were produced by the Frenchman Joseph Nicéphore Niepce. In the early years of the 19th century Niepce, an amateur scientist, inventor and artist, became interested in the then new techniques of lithography. Not very good at drawing, he began to explore ways of producing images directly on the printing plate or stone. Like Wedgwood before him Niepce first tried sensitizing paper with silver chloride; in 1816 he was able to record faint

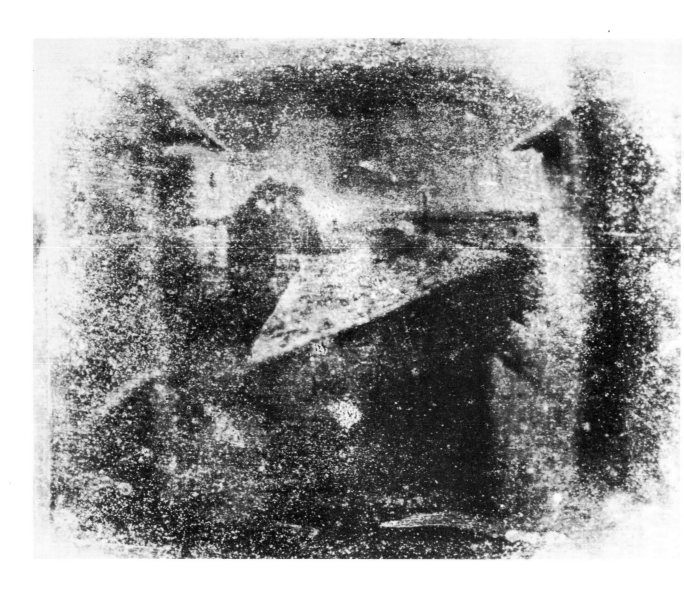

A heliograph made in the camera by Niepce, probably in 1827, of the view from a window of his house at Saint-Loup-de-Varennes. The surface irregularities of the original plate have been emphasized by the technique required to copy the very faint original

images in the camera obscura, but was unable to make the pictures permanent. He then tried coating metal plates with various acid-resisting substances, hoping to make printing plates. He discovered that a coating of varnish made by dissolving bitumen of Judea (a kind of asphalt) in a suitable solvent was sensitive to light. Since the varnish hardened if exposed for a long period, if the coated plate were placed under an engraving on translucent paper the lines of the picture protected the bitumen from light and it remained soft. Where light passed through the engraving, the bitumen hardened and became insoluble. After exposure the plate was washed with a mixture of light petroleum and lavender oil, which dissolved away the soft unexposed parts of the coating, leaving a permanent image on the plate. Niepce's first 'heliographs' were produced in 1822; in 1826 or 1827 he succeeded in recording an image on a bitumenized pewter plate in a camera obscura. An eight-hour exposure produced a faint but iden-

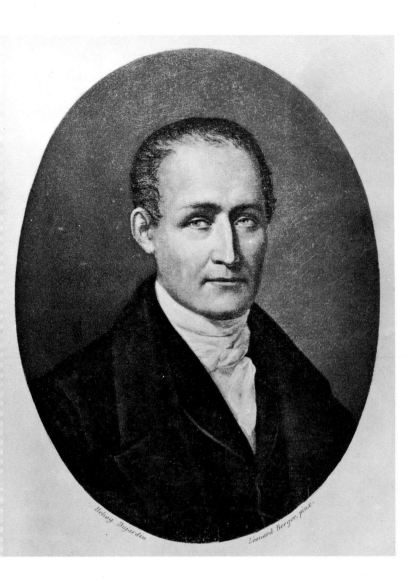

*Joseph Nicéphore Niepce, the pioneer who succeeded in
producing the first permanent photographic image*

tifiable image of the scene from an upper window
of Niepce's home at Saint-Loup-de-Varennes,
in France. This photograph, the oldest surviving
image produced in a camera, is preserved in the
Gernsheim Collection at the University of Texas.

Niepce's heliographic process was quite im-
practicable for normal photography due to the
very long exposures required, although, in a
modified form, it was used later for the produc-
tion of plates for printing – his original aim.
From a collaboration with another inventor was
to come a new method, evolved from the helio-
graph but much more practical.

2 The first practical process

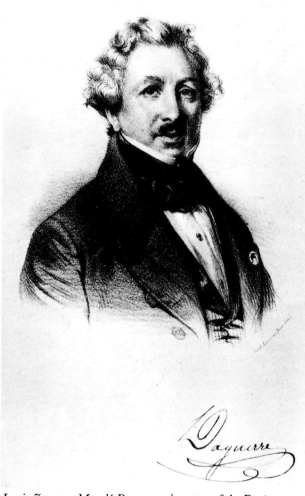

Louis Jacques Mandé Daguerre, inventor of the Daguerreotype, the first practical photographic process

Louis Jacques Mandé Daguerre was a scenic painter who, in 1822, had introduced the Diorama, a spectacular illusion for the theatre. Huge translucent paintings were given dramatic effect by changing the direction, intensity and colour of the lighting and by movement. To prepare the necessarily realistic images required, Daguerre made use of the camera obscura. Perhaps as a result he began experiments aimed at directly capturing the optical image. By chance he obtained optical equipment from the optician Chevalier, who was also supplying Niepce. Indiscreetly Chevalier told Daguerre of Niepce's experiments, and in June 1826 Daguerre wrote to Niepce. Cautious at first, Niepce corresponded with him until 1827 when, on his way to England to show his heliographs, he met Daguerre in Paris. On his return Niepce concluded an agreement with Daguerre, on 4 January 1829. They agreed to share information and to work together to develop a satisfactory process. Four years later Niepce died, before any material progress had been made. His son Isidore continued the partnership, but it was not until 1837 that a satisfactory process was developed by Daguerre.

He had continued to work with metal plates and discovered that a silver plate, after careful polishing, could be made light-sensitive by exposing it to iodine vapour. Exposure of many minutes in the camera produced no visible image, but Daguerre discovered that a 'latent' image formed in the silver iodide layer by the action of light could be revealed by treating the plate with the fumes of heated mercury. The mercury vapour formed an amalgam with the minute specks of silver produced by exposure to light, and thus intensified, the image became

visible. To make the image permanent the unused silver iodide was removed by using a strong hot salt solution. The image was formed by the whitish silver-mercury amalgam reproducing the light parts of the subject, while the dark areas were represented by the polished silver surface, when it was held to reflect a dark ground. The viewing angle was critical; the Daguerreotype, as the process was named, was aptly called 'the mirror with a memory'.

Daguerre's discovery was announced by the French scientist François Arago on 7 January 1839. In return for a pension of 6,000 francs, with a further 4,000 to Isidore Niepce, Daguerre was persuaded to publish full details of the process on 19 August 1839. The Daguerreotype process could be used freely throughout the world – except in England, where it had been patented on 14 August, just before publication in France. Users in England would have to obtain a licence from Daguerre. The Daguerreotype process was immediately popular; suppliers of apparatus and materials were besieged by customers anxious to try their hand at picture making. The art world was astonished and disturbed. It is said that the painter Paul Delaroche, on seeing a Daguerreotype, exclaimed, 'From today, painting is dead!" However, the process was imperfect in several respects. In particular the prepared plates were very insensitive. Even in the brightest sunshine an exposure of many minutes was needed, making portraiture very difficult.

In 1840 John Goddard, an English science lecturer, discovered that by treating the silvered plate with bromine vapour as well as iodine the silver bromide-silver iodide coating formed was very much more sensitive to light. Antoine Claudet, in the following year, showed that chlorine had a similar accelerating effect. These double sensitizing techniques greatly reduced the exposure times required.

The simple lenses fitted to the first Daguerreotype cameras had limited light-gathering powers. In 1840 Josef Petzval of Vienna computed a new lens design, the first created specifically for photography. Four glass elements were combined to produce a lens with a large aperture (about f/3·6 in modern calibration), transmitting about 16 times more light than did the simple lens on Daguerre's first camera. The Petzval lens was first incorporated in an all-metal camera designed by Peter Voigtländer and sold from January 1841. As a basic lens design it has remained in use ever since. The combination of

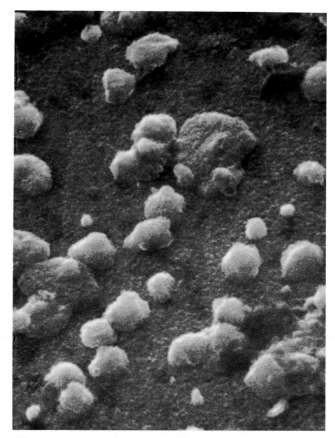

The Daguerreotype image, magnified more than 13,000 times. The particles of mercury-silver amalgam forming the image are extremely vulnerable to damage

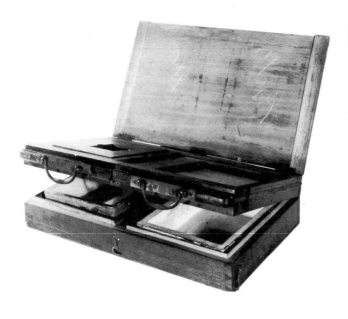

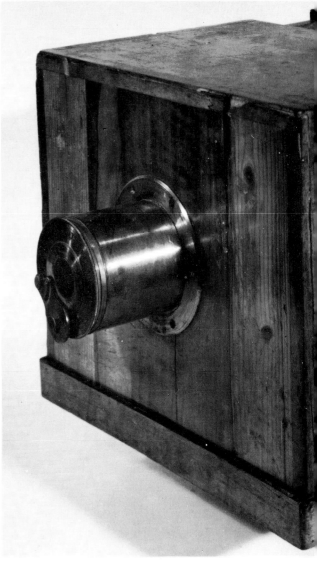

the improved lenses and double sensitizing brought exposure times down to well under a minute in normal conditions.

Another drawback of the early Daguerreotype process was the fragile nature of the image, formed of tiny particles of soft silver-mercury amalgam on the surface of the silver plate. The image could be destroyed at the slightest touch. In 1840 Hippolyte Fizeau discovered that by treating the processed image with a heated solution containing gold chloride, not only was the tone of the image improved, but it became much less easily damaged. Soon gold toning was standard practice in the Daguerreotype process.

To prepare, expose and process the Daguerreotype plate a considerable amount of apparatus and manipulation was required. First the plate, usually of silvered copper, was held in a hand vice and polished on a leather buff, using powdered pumice stone and olive oil. It was finished to a high polish with jeweller's rouge. The plate was then placed face down in a sensitizing box, usually with two compartments for iodine crystals and bromine water. Close observation of a succession of colour changes on the plate's surface during this operation told the operator when the desired degree of sensitivity had been reached. The prepared plate, loaded in a plateholder, was then placed in the camera. (Usually the Daguerreotype camera consisted of two wooden boxes, one sliding closely within the other. One carried the lens and the other the focusing screen and plateholder. The first cameras, made and sold by Daguerre's relative, Alphonse Giroux, all bore Daguerre's signature

and Giroux's seal as authentication and guarantee.) When the plate had been exposed, usually for about 30 seconds in the studio, it was removed from the camera and taken to the darkroom, where it was placed face down in the top of a developing box. In the bottom was a dish of mercury, heated by a spirit lamp. As the mercury vapour 'developed' the image, progress could be followed by candlelight through a yellow glass window in the box. When fully developed the image was fixed by chemical treatment, removing the remaining unused silver salts. The plate was placed on a levelling stand to keep it perfectly horizontal, covered with gold-bearing solution and heated. Finally after washing and drying, the finished plate was covered with a gilt or brass matt – a decorative mask with an appropriately shaped aperture – covered with a protective glass and bound in a pinchbeck or brass foil frame. An airtight seal

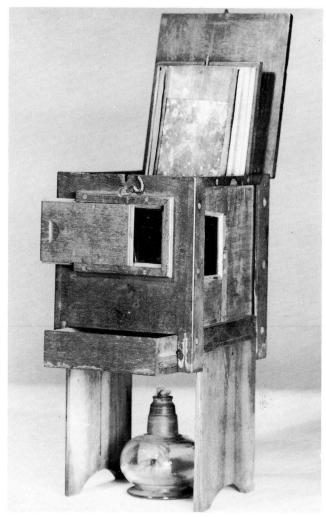

was necessary, as the silver plate would tarnish rapidly if exposed to the atmosphere. The mounted Daguerreotype was usually sold in a leather-covered, plush-lined case.

From 1854 a new kind of protective case became popular. Known as a Union case, from its American origin, it carried a finely detailed design, made by pressing a hot, soft mixture of shellac and sawdust or a similar filler into a steel die. When cold the mixture set hard, retaining all the details of the die. This early form of thermoplastic moulding (a technique widely used today) gave fine results, the designs often being based on well-known paintings.

The Daguerreotype process remained in general use in Europe until the middle 1850s, although it enjoyed a rather longer life in the United States. It was capable of beautiful results but had some inherent drawbacks. The materials and apparatus used, with the lengthy

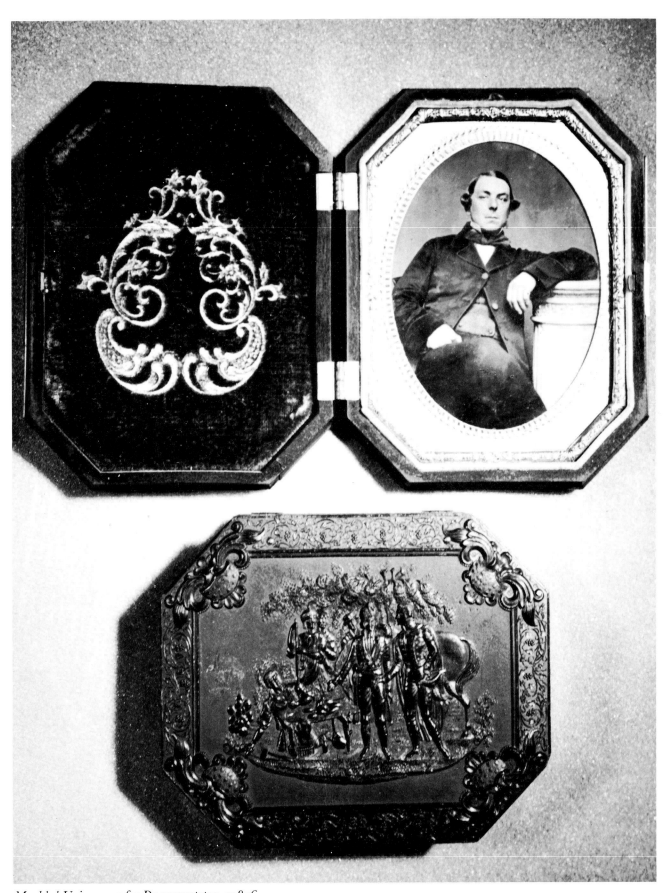

Moulded Union cases for Daguerreotypes, c1856

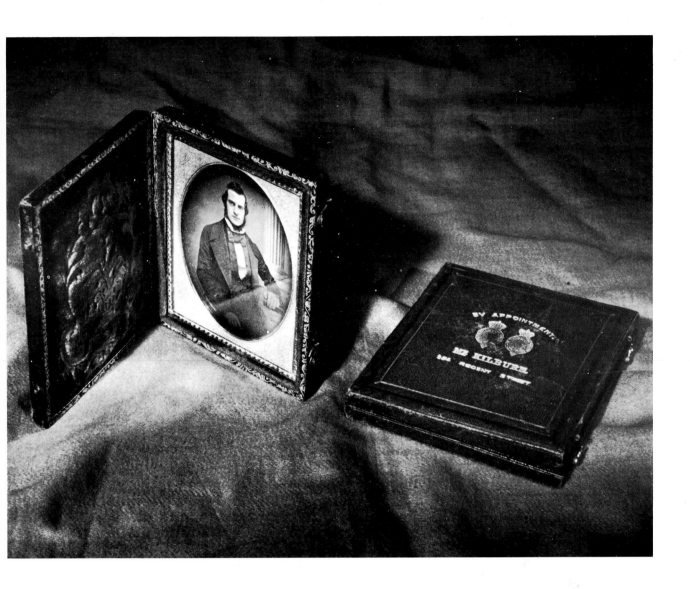

Finished Daguerreotypes, in protective cases. These often carry the photographer's name

manipulations required, made it expensive to operate. In 1854 the basic equipment required could cost at least six guineas, while a complete professional outfit might cost over a hundred pounds. A small portrait Daguerreotype, two inches by two and a half, usually cost a guinea; the cost of larger sizes increased proportionately. Each picture was unique; if more than one were needed, extra originals had to be taken at full cost or, less satisfactorily, the original could be copied in a camera. The Daguerreotype image was laterally reversed, as in a mirror. If a right-way-round picture was required a mirror or prism was interposed between the sitter and the lens.

The Daguerreotype was the first photographic process to be widely used but it was not from this that modern photography evolved. Daguerre's beautiful but complicated process was obsolete within 20 years of its discovery, killed by a principle introduced by his contemporary, W. H. F. Talbot, an Englishman.

3 The origins of modern photography

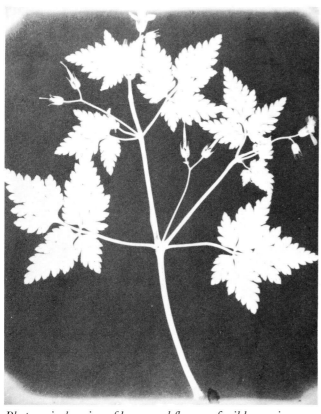

Photogenic drawing of leaves and flowers of wild geranium, c1839, by W. H. F. Talbot

William Henry Fox Talbot was inspired to develop a photographic process through his lack of success as an amateur artist. This is how he described his discovery:

"One of the first days of the month of October 1833, I was amusing myself on the lovely shores of the Lake of Como, in Italy, taking sketches from Wollaston's Camera Lucida, or rather I should say, attempting to take them; but with the smallest possible amount of success. For when the eye was removed from the prism – in which all looked beautiful – I found that the faithless pencil had only left traces on the paper melancholy to behold . . . I then thought of trying again a method which I had tried many years before . . . to take a Camera Obscura, and throw the image of the objects on a piece of transparent tracing paper laid upon a pane of glass in the focus of the instrument . . . It was during these thoughts that the idea occurred to me . . . how charming it would be if it were possible to cause these natural images to imprint themselves durably, and remain fixed upon the paper! And since, according to chemical writers, the nitrate of silver is a substance peculiarly sensitive to the action of light, I resolved to make a trial of it . . . In January 1834, I returned to England from my continental tour and soon afterwards . . . I began by procuring a solution of nitrate of silver, and with a brush spread some of it upon a sheet of paper, which was afterwards dried. When this paper was exposed to the sunshine I was disappointed to find that the effect was very slowly produced in comparison with what I had anticipated.

"I then tried the chloride of silver, freshly precipitated and spread upon paper while moist. This was found no better than the other,

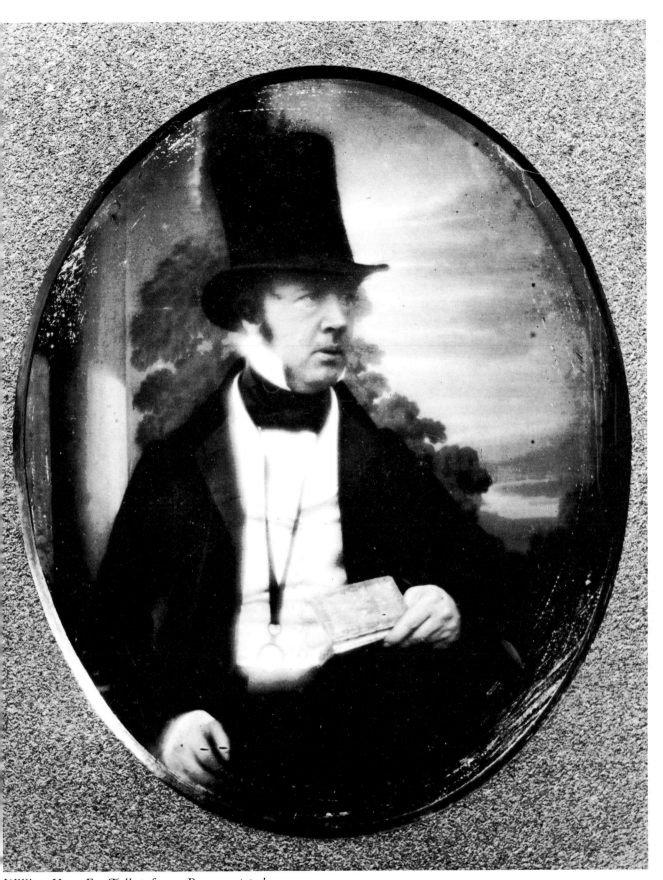

*William Henry Fox Talbot, from a Daguerreotype by
Claudet*

23

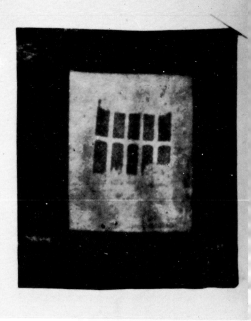

*Latticed Window
(with the Camera Obscura)
August 1835

When first made, the squares
of glass about 200 in number
could be counted, with help
of a lens.*

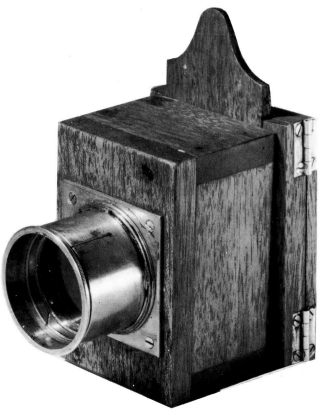

Top *The oldest surviving negative, made by W. H. F. Talbot in August 1835*

Above *A 'mousetrap' camera of the type used by Talbot between 1835 and 1840*

turning slowly to a darkish violet colour when exposed to the sun . . .

"A sheet of paper was moistened with a much weaker solution of salt than usual, and when dry, it was washed with nitrate of silver. This paper, when exposed to the sunshine, immediately manifested a far greater degree of sensitiveness than I had witnessed before, the whole of the surface turning black uniformly and rapidly: establishing at once and beyond all question the important fact, that a lesser quantity of salt produced a greater effect . . . In the spring of 1834, no difficulty was found in obtaining distinct and very pleasing images of such things as leaves, lace, and other flat objects of complicated forms and outlines, by exposing them to the light of the sun . . ."

His observation that an excess of salt reduced the sensitivity of his paper led Talbot to a method of fixing his images by treatment with a strong salt solution. His photogenic drawings, as he called them, were thus made tolerably permanent. This suggested a further development. In February 1835 he recorded in his notebook: "In the Photogenic or Sciagraphic process, if the paper is transparent, the first drawing may serve as an object, to produce a second drawing, in which the lights and shadows would be reversed." He had discovered the principle on which modern photography is based – the negative which could be used to print many positives (these terms were suggested to Talbot in 1839 by the astronomer, Sir John Herschel).

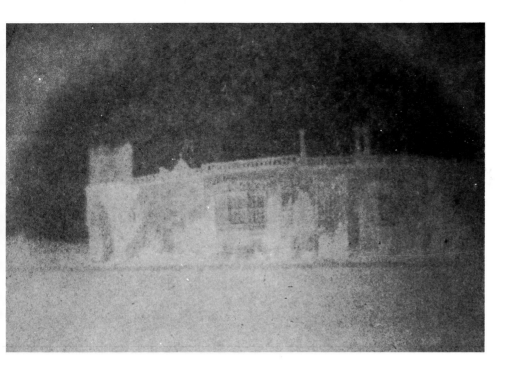

Top *Photogenic drawing negative of Lacock Abbey, by Talbot, probably in 1836*

Above *'Bowood', a positive photogenic drawing by W. H. F. Talbot, 14 April 1840*

His notes in February 1835 record another idea: "If an object, as a flower, be strongly illuminated, & its image formed by a camera obscura, perhaps a drawing might be effected of it, in which case not its outline merely would be obtained, but other details of it. For this purpose concentrated solar rays might be thrown on it:

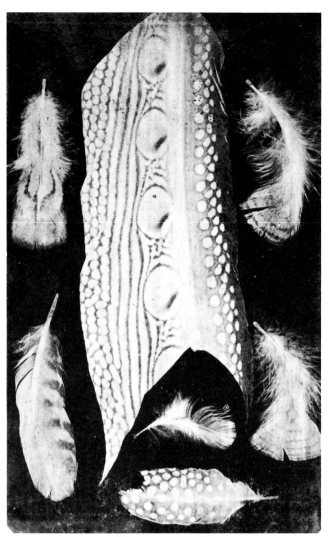

Photogenic drawing of feathers, by Sir John Herschel, probably in 1839

viving picture taken in one, in August 1835, showing a lattice window, is now in the Science Museum, London.

Talbot became involved with other projects and for a few years did little work on his new process, until he was surprised and shocked to hear of Daguerre's discovery in January 1839. To establish his prior claim he arranged with Michael Faraday to display examples of photogenic drawings – leaves, lace and camera pictures – at the Royal Institution in London on 25 January 1839. He presented a paper, *Some account of the art of Photogenic Drawing*, to the Royal Society on 31 January 1839, followed by a second paper on 20 February giving details of his method. This was the first publication of the description of any photographic process.

Sir John Herschel had been inspired by the reports of Daguerre's and Talbot's work to carry out experiments of his own. He realized that sodium thiosulphate (then known as hyposulphite of soda), whose property of dissolving silver salts he had discovered in 1819, would make an ideal material for fixing the photographic image. He accordingly wrote to Talbot about it on 1 February 1839. With Herschel's permission Talbot published the new fixing method in a letter to *Comptes Rendus*, the journal of the French Academy of Sciences. Daguerre immediately adopted the new method but because it was expensive and reduced the density of the already faint photogenic drawings Talbot did not use it for some time, persisting with the less efficient methods of fixing with salt, potassium iodide or potassium bromide.

The photogenic drawing process was far from perfect. In particular the paper was very insensitive, many minutes or even hours being needed to produce an adequate negative in the camera. But in September 1840 Talbot discovered that, as with the Daguerreotype, a latent image formed by brief exposure to light could be revealed by development. Fine writing paper was first treated with silver nitrate solution, followed by potassium iodide solution, forming light-sensitive silver iodide in the paper fibres. Before exposure the paper was given extra sensitivity by washing it with a mixture of silver nitrate and gallic acid solutions. An exposure of only a few minutes was enough to form an image which was revealed when the paper was again treated with the silver nitrate/gallic acid solution. Since the new process gave a much stronger image than the photogenic drawing paper, fixing in 'hypo' solution was practical.

but best employ only violet light because we want chemical rays and not heating rays lest the flower should be scorched by their intensity". This experiment he carried out in the summer, as he later recorded: "During the brilliant summer of 1835 in England I made new attempts to obtain pictures of buildings with the Camera Obscura; and having devised a process which gave additional sensibility to the paper, viz. by giving it alternate washes of salt and silver, and using it in a moist state, I succeeded in reducing the time necessary for obtaining an image with the Camera Obscura on a bright day to ten minutes".

Talbot's first camera pictures were of Lacock Abbey, his Wiltshire home. He made some small wooden cameras, taking pictures about one and a half inches square. Finding the cameras scattered over the house and grounds, his wife christened them 'mousetraps'! The oldest sur-

Very early Calotype print of Lacock Abbey. The negative was probably made on 24 September 1840, the day after Talbot's discovery of the development process

Calotype negative and positive of Lacock Abbey, by Talbot, c1843

After washing and drying, the paper negative was usually waxed to make it translucent for printing.

Prints from the negative were made by a variation of the photogenic drawing process. Paper was soaked in a solution of common salt and dried. The salted paper was sensitized when required by treatment with silver nitrate solution. The dried prepared paper was placed in close contact with a negative in a printing frame and was exposed to strong daylight, preferably sunlight. Exposed under the negative, the salted paper rapidly darkened in inverse proportion to the density of the negative, giving a positive image. When the desired density had been reached, the paper was removed from the frame, fixed and washed.

Talbot called his new process 'Calotype' (from a Greek root meaning beautiful), although it soon became widely known under the alternative honorary name of 'Talbotype'. In 1841 he applied for a patent for the process and all who wished to use the Calotype process had to apply for a licence. To some extent this inhibited the use of the process, especially for commercial portraiture, where, because of the long exposures required, the Calotype was already at a disadvantage compared with the Daguerreotype. However, Talbot allowed amateurs free use of his method. Between 1844 and 1846 the process was publicized in a six-part publication, *The Pencil of Nature*, written by Talbot and illustrated with 24 original Calotype prints pasted into the text. It was the first published book to be illustrated with photographs. The prints were produced in quantity at an establishment set up at Reading; most were still-life, landscape or architectural subjects. One, 'The Ladder', included human figures, and in the text Talbot wrote, "I have observed that family groups are especial favourites . . . What would not be the value to our English nobility of such a record of their ancestors who lived a century ago? On how small a portion of their family picture galleries can they really rely with confidence!" However, the Calotype never seriously competed with the Daguerreotype for portraiture and it was employed principally by amateurs, especially travellers, for whom the simpler manipulations and lower cost of the paper negative process were great advantages. The process was well suited to architectural and landscape photography.

In 1851 Gustave Le Gray introduced an important improvement. He found that by waxing the paper *before* sensitizing, the keeping proper-

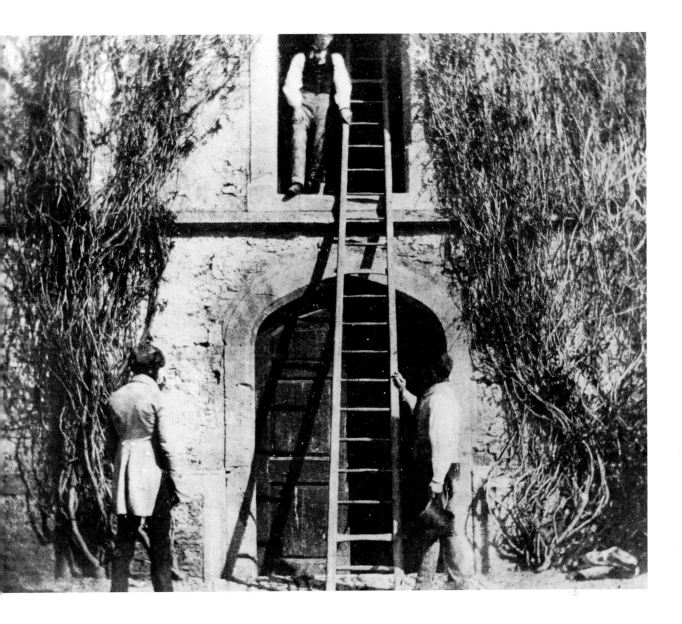

ties of the negative paper were greatly improved. Calotype paper had to be exposed soon after sensitizing, preferably while still moist; waxed negative paper could be kept for days or weeks before exposure without loss of quality. The waxed paper negative was also capable of recording very fine detail, although it was much less sensitive than the Calotype paper.

In 1852 Talbot relinquished his patent rights in the paper negative process for all uses except commercial portraiture and for a few years the process and its variations enjoyed new popularity, especially in England and France. It was little used in America, where the Daguerreotype had reigned. But, like the Daguerreotype, the Calotype was destined to disappear. A new process, evolved from the negative-positive principle of the Calotype, but without its limitations, was to replace them both.

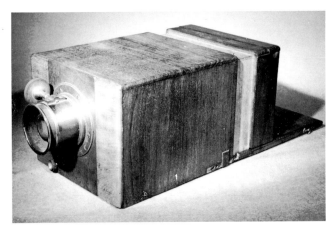

Top *'The Ladder', Plate 14 from Talbot's* The Pencil of Nature, *1844*

Above *A sliding-box camera for the Calotype process, c1850*

4 Wet~plate photography

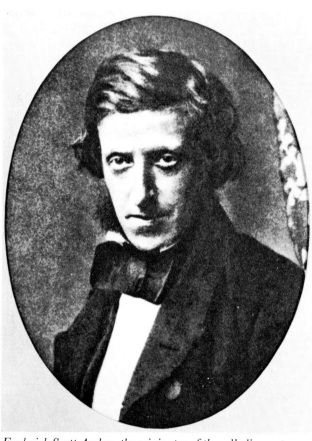

Frederick Scott Archer, the originator of the collodion wet-plate process

The advantages of easy duplication brought by the paper negative were to some extent outweighed by its disadvantages. The paper fibres imparted a distinct mottle to areas of even tone on the print, even when the negative had been waxed, limiting the resolution of fine detail. It was realized that the problem would not exist if glass could be used as a support for the sensitive material. Since glass, unlike paper, is not absorbent, a suitable coating had to be found to carry the light-sensitive salts.

Sir John Herschel had made an image on glass in 1839, by precipitating silver chloride onto a glass plate in a process which took several days of preparation. For this reason it was not a practical process, although a picture taken by Herschel in September 1839 is preserved in the Science Museum, London. The first generally successful glass-plate process was introduced in 1847 by Abel Niepce de Saint-Victor, a cousin of Nicéphore Niepce. He found that eggwhite – albumen – coated on glass provided a suitable medium for sensitive salts. A carefully cleaned glass plate was coated with a solution of potassium iodide mixed with albumen. When dry the plate was sensitized when required with an acidified silver nitrate solution. The exposed plate was developed with gallic acid. The albumen plate was very insensitive, but had exceptional resolving power, particularly valuable in architectural photography. Albumen plates were also used for making lantern slides for projection and, later, for transparencies for stereoscopes.

In March 1851 Frederick Scott Archer, an English sculptor and Calotype photographer, described in *The Chemist* a new process using collodion. This recently discovered material was made by dissolving a form of gun-cotton in

30

ether. A quantity of collodion containing potassium iodide was poured onto a perfectly clean glass plate. By tilting the plate the collodion was made to flow evenly over the surface. When the ether had almost evaporated, leaving a tacky coating, the plate was plunged into a bath of silver nitrate to sensitize it. The still wet plate was loaded into a plateholder and exposed in the camera; if left to dry, almost all its sensitivity was lost. Immediately after exposure the plate was developed, fixed and washed. The collodion negative could record fine detail and subtle tones and had the great advantage of being much more sensitive than either the Daguerreotype or Calotype processes. Exposure times were reduced to a few seconds. Scott Archer published his process freely and derived no personal benefit from it. He died penniless in 1857, having seen his process revolutionize photography.

In a book published in 1852, Scott Archer described a variation of his process in which the collodion negative was whitened by treatment with a solution of mercuric bichloride. If the image were backed with black varnish, paper or velvet, by reflection the negative image appeared positive. The collodion positive, or Ambrotype as it was known commercially in America, soon

Top *An early collodion positive, with the photographer's advertisement on the back*

Above *A collodion 'positive' with the black backing partly removed to show that the image is negative*

became very popular for portraiture. Unlike the Daguerreotype process it required little skill and a very modest investment in apparatus and materials. No licences were needed for its commercial operation. Portrait studios opened in any premises that could be found. Hairdressers, butchers, tobacconists, coffee sellers and even dentists were among those offering framed photographic likenesses for as little as sixpence, sometimes with a cup of coffee or a cigar thrown in! Like the Daguerreotype the glass collodion positive required the protection of a matt, cover glass and frame or case, but the quality of work was generally not as good. However, the difference in cost was considerable, and even the poor

could be tempted into a photographic studio for a sixpenny portrait. The process remained popular well into the 1880s.

A variation of the collodion positive process was carried out using black enamelled tinplate instead of glass. First described by the French photographer Adolphe Martin in 1853, the process became popular around 1860 under the name ferrotype or, particularly in the United States, tintype. It was much employed by itinerant photographers who could prepare, expose and finish a positive picture on brown or black enamelled tinplate in a few minutes. Specially designed cameras were introduced in which all the chemical operations were carried out inside

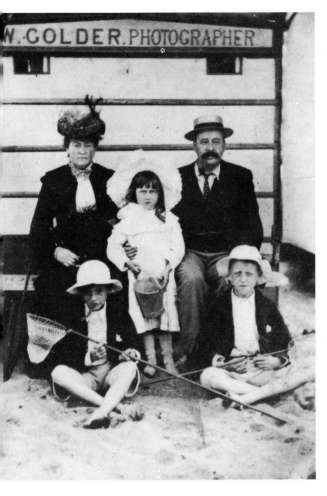

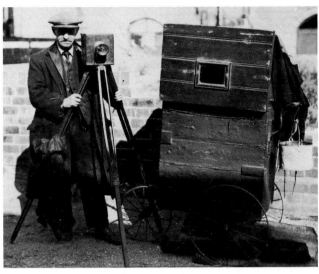

Survey Photographic Building, Southampton, 1859

Above left *A ferrotype of a family at the seaside, c1890*

Below left *Carte de visite photographs by Disderi, c1860*

Above *An itinerant ferrotype photographer*

Four carte de visite poses on a single plate before editing and trimming, c1870

34

the camera. Although ferrotypes were rarely of good quality they were the cheapest form of photograph in their day. With this process, beach and fairground photographers recorded many people who would not have gone near a photographic studio. The process remained in use until after the Second World War.

Although cheap and easy to produce, collodion positives suffered from some of the drawbacks of the Daguerreotype. Each was unique and required a protective case. Of course, the glass negative could be printed on the salted paper used for the Calotype process but in 1850 Louis-Désiré Blanquart-Evrard had published the description of an important improvement. By coating paper with albumen containing ammonium chloride before sensitizing with silver nitrate, a smooth, slightly lustrous surface was achieved. The new process improved the ability of the paper to record fine detail and the albumen paper print was rather less prone to fading than the Calotype. The albumen printing paper was ideal for the glass collodion negative and remained in almost universal use until the 1890s. The prepared paper was placed in close contact with the negative in a printing frame and exposed directly to strong daylight. When the desired density had been reached the print was removed from the frame in the darkroom, fixed in 'hypo' and, usually, toned – a chemical process using gold, giving the image a rich sepia or chocolate-brown colour and also helping to improve its permanence.

Although the printing process was simple enough, the extra work involved made the paper print more expensive at first than the collodion positive. In 1854 André Adolphe Disderi, a Parisian photographer, patented a method by which several portraits could be photographed on a single plate. One printing operation thus produced a number of prints, greatly reducing the cost. Disderi popularized a small mounted print size of approximately four inches by two and a half, which, from its size, became known as the carte de visite photograph. It became widely popular around 1860, and a craze soon developed for collecting carte photographs of celebrities, as well as those of one's friends and relations. Photographers vied with one another to photograph the famous and infamous, supplying from stock pictures of royalty, artists, churchmen, writers, actors and actresses, politicians and even well-known courtesans. Some photographs ran into editions of thousands, especially pictures of the English Royal Family.

Cabinet photographs, like the smaller cartes, usually had elaborately printed mounts

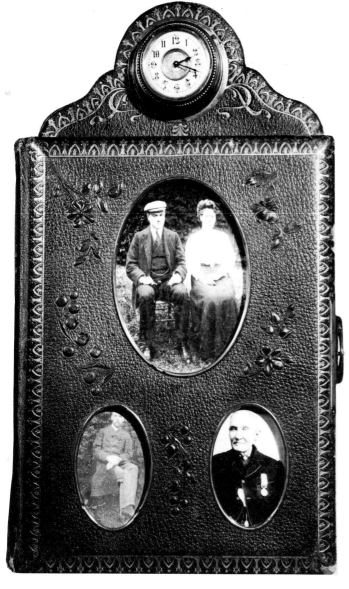

The portraits were taken either with multiple-lens cameras exposing four, six or more pictures simultaneously, or with a single-lens camera taking photographs in succession on a plate moved between exposures. The prints were mounted on cards, often with elaborately printed backs. The poses, usually full-length in the early examples, are often stereotyped and wooden in appearance, varying only in the features of the sitters and in a limited range of backdrops and studio furniture. Photographers of quality charged one guinea for 12 cartes, including the sitting. The carte de visite remained in general use until well into this century but after 1866 it began to give way in popularity to the 'cabinet' photograph, similar in presentation and appearance to the carte but much bigger, about four inches by five and a half. The cabinet photograph was a more suitable size for quality portraiture; a dozen cabinets usually cost about two guineas.

The trend from cased photographs towards the paper print created a demand for albums in which to keep them. The pages of stiff board had apertures cut to hold cartes and, later, cabinet photographs. The album frequently had ornate covers; mother of pearl, plush, tooled leather, carved wood and japanese lacquer were among the materials used. Some albums for display on mantelshelf or table had built-in clocks; others had musical-box movements which played as the pages were turned.

The wet collodion process and albumen printing paper revolutionized photography. By 1860 the Daguerreotype and Calotype processes were virtually obsolete. The wet-collodion negative plate was very sensitive and gave finely detailed pictures – but there was one big drawback. The need to expose the plate while still wet meant that the photographer had to carry his darkroom with him if working away from home. Portable darkrooms were sold, usually in the form of tent-like structures which collapsed into boxes the size of a large suitcase. When fully erected they were big enough for the photographer to get his upper body into, while daylight was excluded by a canvas light-trap. As well as the dark tent the photographer had to carry the chemicals for coating, sensitizing, developing and fixing, a supply of cleaned glass plates, dishes and tanks and a container for water, which also had to be carried if none was to be found on the location. Of course, the photographer also needed to carry his camera, plateholders and tripod. From around 1860 the heavy and bulky sliding body

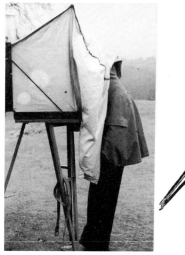

Top *A photograph album with a built-in clock, c1890*

Above *In the portable dark-tent, the photographer coated and processed his plates on the spot; modern reconstruction* left *and contemporary engraving* right

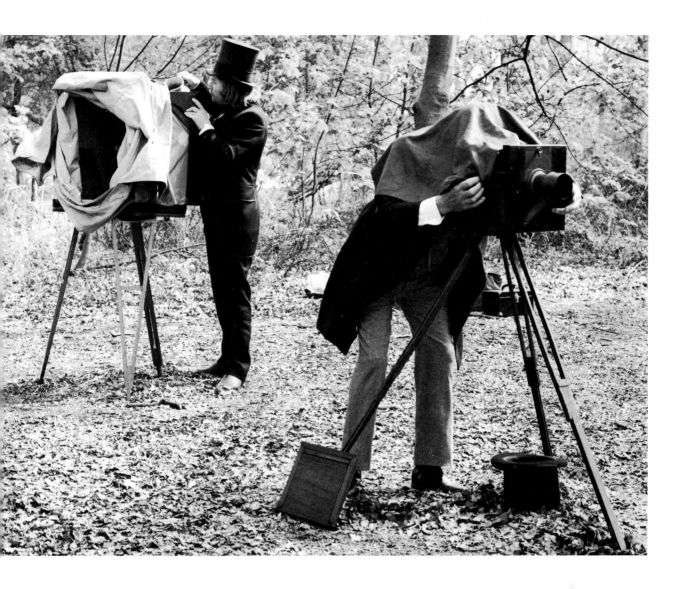

camera typical of the Daguerreotype period rapidly gave way to the folding bellows type. By this ingenious design a camera, quite large when erected, could be made to collapse into a small, lightweight package. All this paraphernalia was necessary for a single photograph; it was cumbersome and expensive. A complete outfit for the travelling photographer could easily cost more than £40.

If a reliable method could be found to prepare plates in advance, with no loss of speed or quality, a great saving in cost and weight could be made. The whole operation would also be much simpler. The photographer would need only a camera, tripod and a few dry plates. The search for an improved dry process went on.

A modern reconstruction showing a photographer using the wet collodion process.

5 The gelatin dry plate

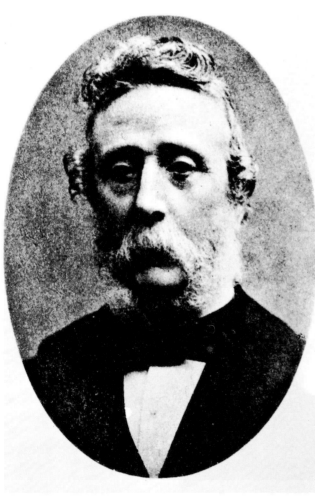

Dr Richard Leach Maddox, the founder of the gelatin dry-plate process

In early attempts to create a dry-plate process photographers used a variety of substances to keep the collodion plate moist for longer periods. Among the extraordinary variety of materials used were liquorice, sugar, beer, glycerine and even raspberry syrup, but no really successful 'dry' process appeared as a result. In 1855 J. N Taupenot published details of a process using sensitized layers of both albumen and collodion. The collodio-albumen plate was very slow, but capable of fine resolution and could be kept for weeks before exposing. By making an 'emulsion' of silver bromide in collodion, and coating the mixture on a glass plate, W. B. Bolton and B. J Sayce found in 1864 that the dried plates could be kept for long periods before exposure without loss of quality. Like all the dry-collodion processes the collodio-bromide plates were less sensitive than the wet process but from 1867 The Liverpool Dry Plate and Photographic Printing Company sold precoated plates made by this process.

The first account of a really satisfactory dry-plate process was published by Dr Richard Leach Maddox of London. An enthusiastic photographic experimenter, he found that the ether vapour of the wet-collodion process affected his poor health and he searched for a substitute for collodion. He turned to gelatin, a substance that had been employed before in photography, notably as a sizing agent used in the preparation of papers suitable for the Calotype process. Attempts had been made to use it as a direct substitute for collodion but with no success. Dr Maddox found that by mixing cadmium bromide and silver nitrate in a warmed solution of gelatin an emulsion of silver bromide was formed in the gelatin. Coated on glass plates

and dried, this sensitive material retained its properties for some time after manufacture. The process was published by Dr Maddox in *The British Journal of Photography* on 8 September 1871. As first described, the process was imperfect but it attracted the attention of other experimenters.

In 1873 John Burgess of London advertised for sale ready-mixed gelatin emulsion, based on Maddox's formula, for coating by the photographer. It was not very successful and Burgess did better with ready-coated dry plates, which he sold from August 1873. These early gelatin dry plates were less sensitive than wet collodion and offered no great advantage. In 1874 an amateur photographer, Richard Kennett, put on sale in London a dried gelatin emulsion, which he called 'pellicle', to be reconstituted with water before coating by the user. In the preparation of the 'pellicle', it was dried by heat and, unknown to Kennett, this was responsible for a great increase in sensitivity which was observed in the coated plates. Charles Bennett of London investigated the effect and on 29 March 1878 he published in *The British Journal of Photography* details of a new gelatin dry-plate process. Prepared gelatin emulsion was 'ripened' by prolonged heating, producing a considerable increase in the speed of the emulsion. Bennett's discovery was a major breakthrough. The new dry plates were easily manufactured, very sensitive, and retained their properties for long periods. Exposure times could be reduced to as little as one tenth of those necessary for wet-collodion plates.

For the first time an entirely satisfactory process permitted the manufacture of dry plates for sale. Within months the new plates were being produced by many manufacturers. Among the first in England were Wratten and Wainwright of Croydon, Mawson and Swan of Newcastle and Samuel Fry of Kingston upon Thames. Within a few years the wet-plate process had been discarded by all but a few diehard photographers (although it remained in use in the printing industry until quite recently). Now the photographer no longer needed to carry a dark tent and chest of chemicals when on an excursion; a camera, tripod and a few loaded plateholders were all that was required. The dry plates, bought from a manufacturer as required, were exposed in the field and processed in the darkroom on the photographer's return.

The new process brought about other changes in photography. When the photographer pre-

An advertisement for Kennett's gelatin pellicle, 1875

39

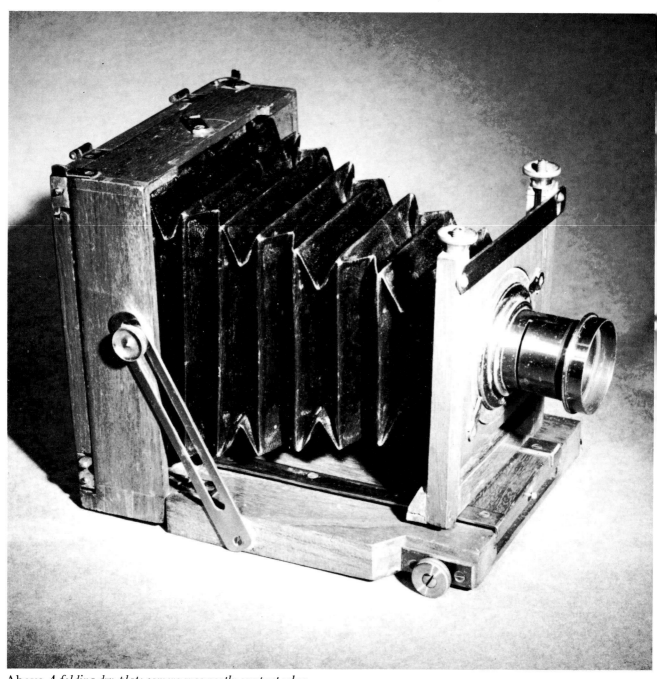

Above *A folding dry-plate camera was neatly compact when closed*

pared his own materials each had his own methods and formulae. Depending upon the method of preparation the exposure for the wet plate would vary. Since the plate was developed on the spot any errors of exposure could be immediately seen and corrected during development, or the photograph could be repeated. The gelatin dry plate could be manufactured in quantity, with consistent characteristics; it was necessary to devise methods of measuring and describing the sensitivity of the plate for the benefit of the photographer. The science of sensitometry, as it is called, was pioneered by Ferdinand Hurter and Vero Driffield in England during the last 20 years of the 19th century. The 'H & D' scale of plate sensitivity remained the standard method of speed determination for a long time.

The manufacture of plates of known and constant sensitivity made it possible and desirable to develop methods of exposure calculation and measurement. One of the most efficient early calculators was the Actinograph, invented by Hurter and Driffield, and sold from 1888. Having assessed the prevailing lighting conditions, the photographer was able to compute with the cal-

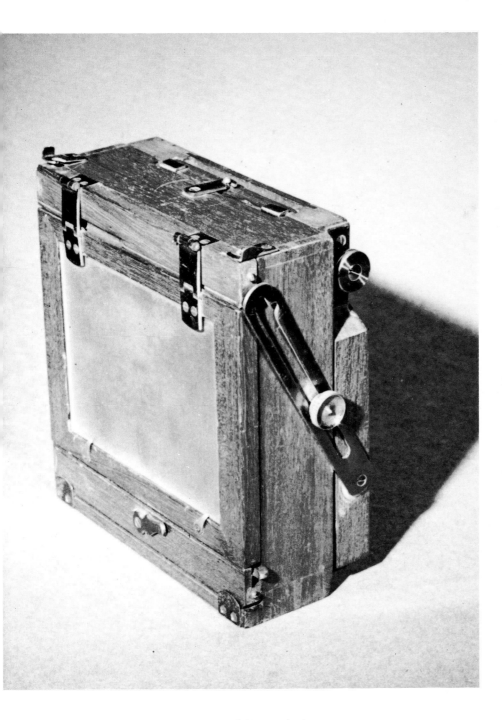

Below *Bennett was the first to manufacture a fully practical
gelatin dry plate*

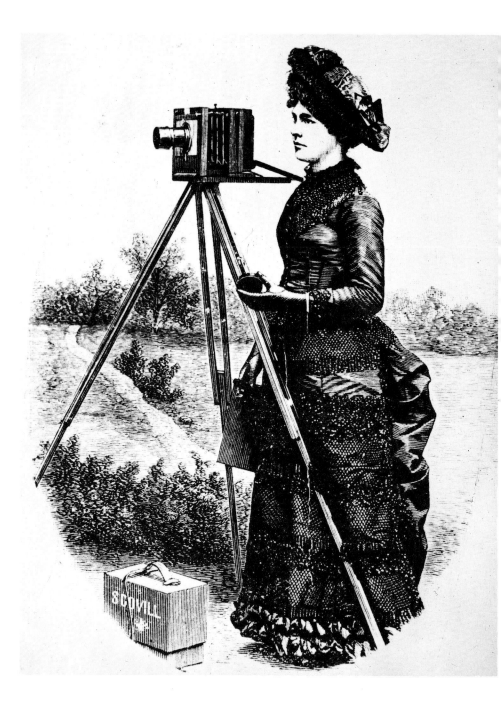

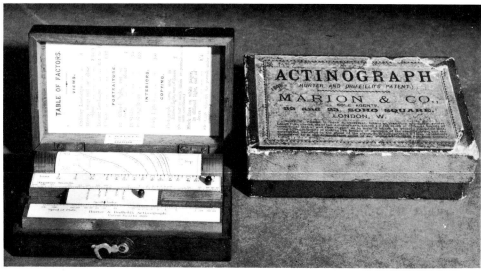

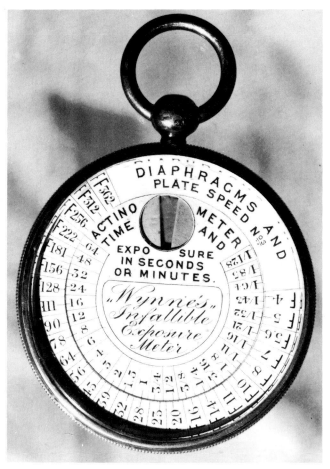

culator the necessary lens aperture and exposure time. The first exposure meters were actinometers, which enabled the photographer to measure the brightness of the light available. They were usually made in the form of a pocket watch, and carried a piece of printing out paper which darkened when exposed to light. The time taken for the paper to darken to match a standard tint was measured, and by applying this information to a calculator the necessary exposure details could be worked out. One of the first actinometers was sold by Stanley of London around 1886, but the most popular English models were the 'Infallible' actinometer made by Wynne, and the later Watkin's Bee meter, first sold around 1900 and in general use until the 1930s.

Among the many radical changes in the practice of photography brought about by the introduction of the gelatin dry plate, the most important was the great reduction in exposure times. For the first time 'instantaneous' photographs of fractions of a second in duration could be achieved without difficulty. The photography of moving subjects, a dream for so long, became practicable at last.

Above left *The greater convenience of the new dry plates encouraged many women to take up photography*

Below left *The Hurter and Driffield Actinograph exposure calculator, 1888*

Above *A Wynne's Infallible actinometer, 1895, with a solid silver case, formerly owned by Alexandra, Princess of Wales, a keen amateur photographer*

6 The photography of action

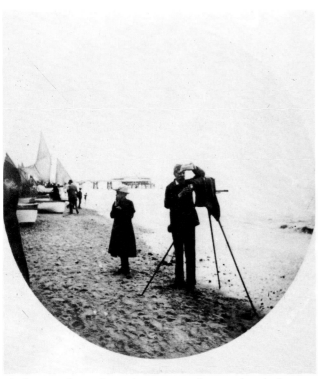

A photographer makes a time exposure by removing the lens cap while shading the lens with his cap

The early photographic processes were all relatively insensitive. Although with each improved process exposure times had been reduced, until the dry plate arrived they were still in seconds or minutes. Exposures of this duration were made normally by removing and replacing the lens cap, the camera being firmly fixed on a tripod or stand. It was impossible to record moving objects; their movement produced a blur on the plate. Early attempts were made to devise an 'instantaneous' process which would enable the photographer to hold the camera and to record action subjects. Thomas Skaife's 'Pistolgraph' camera, introduced in 1856, but subsequently greatly improved, was fitted with a Dallmeyer lens with the exceptionally large aperture of f/1·1, enabling it to pass more than 200 times more light than the conventional landscape lens. This exceptional lens was possible only because of the very small plate used – a curved watch-glass of about one and a half inches in diameter, requiring a lens of about one inch in focal length. A shutter powered by a rubber band permitted exposures sufficiently brief to stop the action of slowly moving subjects. Cameras of this type did not come into general use and the earliest 'instantaneous' photographs to be generally published were stereoscopic views. When stereoscopic photographs of scenes with movement were required, both pictures had to be exposed simultaneously. This led to the fitting of simple shutters over both lenses. Usually of simple design – sliding plates or flaps – these early shutters could be used to give exposures as short as a quarter of a second. This was practical because the small size of the image – about three inches square – required for the magnifying stereoscope made it possible to

use lenses of short focal length and wide aperture. George Washington Wilson of Aberdeen pioneered the photography of street scenes and other action subjects in a series of stereoscopic views published from 1859. It is said that he made his brief exposures by uncovering and covering the camera lenses with his Glengarry bonnet!

Sir John Herschel is usually credited with coining the term 'snapshot' to describe an instantaneous photograph. In *The Photographic News* of 11 May 1860, writing about taking moving pictures, he referred to "the possibility of taking a photograph, as it were, by a snap-shot – of securing a picture in a tenth of a second of time". It is possible that the term may have been already in current use; in a report in *The Photographic Journal* (later to become *The British Journal of Photography*) of 1 July 1859, a report

Top *Movements of flags and people during the time exposure necessary to record celebrations marking the end of the Crimean War produced blurs in this photograph*

Above *A stereo-camera by the London firm of Cox, c1862, fitted with a simple rubber-band-powered shutter*

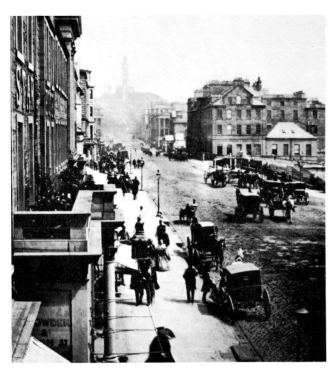

Top *An instantaneous view of Princes Street, Edinburgh, from a stereo-photograph by G. W. Wilson, 1859*

Above *An instantaneous view of a ferry boat on the East River, New York, c1861; from a stereo-photograph by E. & H. T. Anthony*

of a demonstration of Skaife's Pistolgraph camera describes how the demonstrator's assistant "was directed to snap his camera at the skylight". However, the recording of action subjects without the use of special apparatus or techniques was not generally possible until the introduction of the gelatin dry plate.

One of the earliest photographers to make a speciality of action photography, and certainly the best-known, was the Englishman Eadweard Muybridge, who worked for much of his life in America. In the early 1870s Muybridge began a photographic investigation into the locomotion of the horse, using a simple shutter device to take brief exposures on wet collodion plates, but without conclusive success. After a break in his experiments, he succeeded, in 1877, with improved apparatus, in recording a trotting horse with exposures reputedly as brief as a thousandth of a second. Soon after, he created a system of a number of cameras in a row, their rubber-band-assisted drop shutters triggered directly by the moving animal or released electrically in sequence by a suitable timing mechanism. Although Muybridge was the first to put this idea into practice it had been suggested earlier, notably by a Swedish portrait painter, Oscar G. Rejlander. In *The British Journal of Photography Almanac* for 1873 in an article, 'On Photographing Horses', Rejlander referred to the "vexed question" of the exact position of a horse's legs when galloping and suggested a way of solving the problem. "Given a horse and a rider, take a point near or on a sandy or dusty white road, 150 yards off . . . Then I would have a battery of cameras and 'quick-acting' lenses ready charged and loaded. The signal given, the rider starts some distance off the focused point, and at the moment of passing it – bang! with a strong wrist and sleight of hand, the exposure and covering is done . . ." This suggestion was probably seen by Muybridge, and it may have prompted him to devise his successful system some years later. The gelatin dry plate was ideal for his purpose, having great sensitivity and simple manipulation, and in the 1880s he made intensive studies with his batteries of cameras of the movements of animals and men. When published his sequence pictures upset all previously held ideas of the representation of movement. His work led ultimately to the successful introduction, by other inventors, of motion-picture photography in the 1890s.

Professor Étienne Marey, a French physiologist stimulated by Muybridge's work, devised

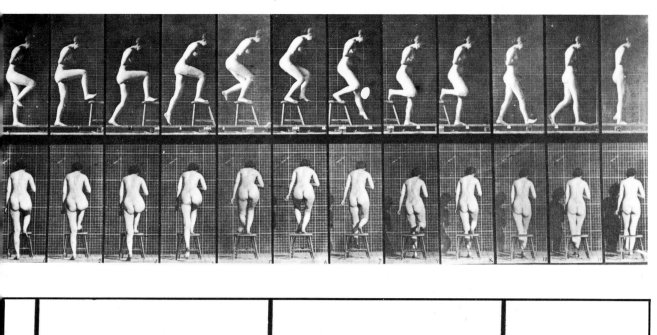

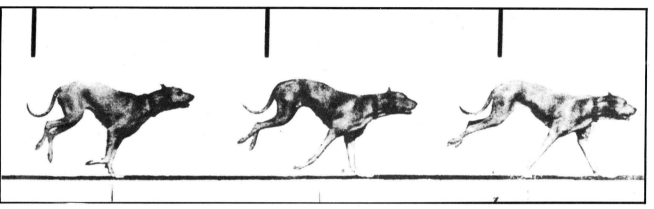

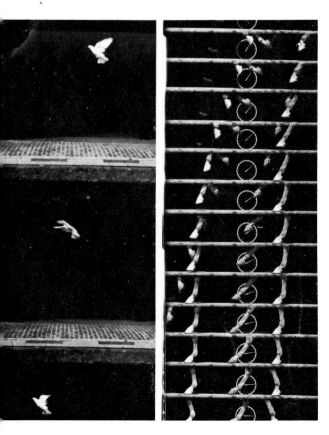

Top *Sequence photographs of a woman climbing a stool, by Eadweard Muybridge, 1887*

Above *Sequence pictures of a dog running, by Ottomar Anschütz, c1888*

Left *Sequence pictures of a bird in flight, and the hooves of a trotting horse, taken by E. J. Marey in his chronophotographic film camera, c1890*

47

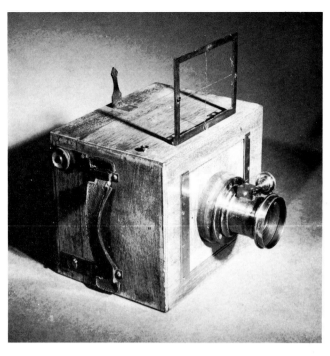

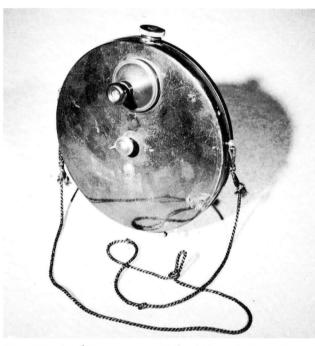

Top *The Anschütz camera, with focal plane shutter, c1890*

Above *The Stirn detective camera, c1886, designed to be worn under the waistcoat, with the lens protruding through a buttonhole*

several cameras in which sequences of image could be recorded on a single plate. His experiments culminated in 1887 in a 'chronophotographic' camera in which long series of action pictures could be recorded on rolls of sensitized material. This device can be considered the first practical cine camera. Like Marey, Ottoma Anschütz, a Prussian photographer, was influenced by Muybridge's work and in 1882 he devised a small hand camera which used a fabric focal plane shutter. This permitted exposures as brief as a thousandth of a second. He produced and published many excellent studies of animals in action and, later, using a battery of cameras, made sequence studies like those of Muybridge. A commercial version of his focal plane camera was sold by C. P. Goerz of Germany in the 1890s.

The great public interest aroused by the publication of the results of these 'chronophotographers' led to the rapid development of hand cameras. At first the larger stand cameras were adapted for hand use by fitting a shutter over the lens and by adding a viewfinder to help to frame the picture. More compact cameras with built in shutters soon appeared. Before long a fashion developed for concealing hand cameras. From the early 1880s so-called 'detective' cameras were disguised as or hidden in parcels, opera glasses, bags, hats, walking-stick handles and many other forms. Some, like the popular Stirn 'Secret' or waistcoat camera, were worn concealed under clothing. To modern eyes few were convincingly disguised but they were sufficiently unlike the traditional stand camera to fool the Victorian non-photographer. Most did not perform very well through limitations of design or of the materials they employed. The glass plate then in universal use was a major drawback. Awkward mechanisms were needed to change a succession of glass plates inside the camera. The weight of the plates and the relatively large size of even the 'detective' cameras were a great inconvenience for all but the most enthusiastic photographer. Although the dry-plate relieved the photographer of the necessity of making his own plates, he still had to process and print them, operations requiring a darkroom and the necessary skills. These problems, and the expense involved, prevented photography from becoming a popular pastime. This was all to be changed by George Eastman.

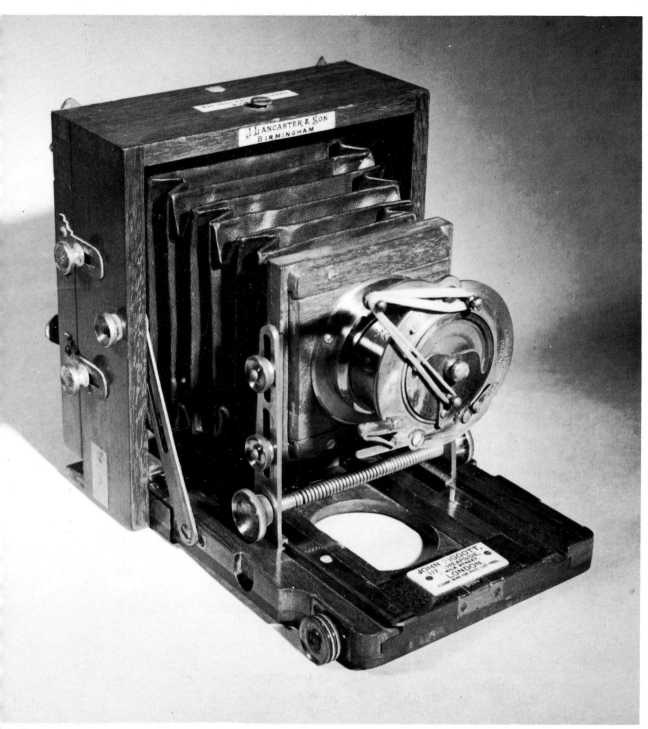

*The Lancaster Instantograph stand camera, 1896, with an
added rubber-band-powered rotary shutter for hand use*

7 The first Kodak camera

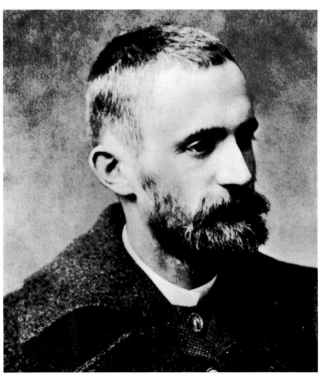

George Eastman, inventor of the Kodak camera

George Eastman, a young American bank clerk, became interested in photography in 1877. He bought a wet-collodion outfit and took lessons from a local professional photographer. He soon became dissatisfied with the messy and cumbersome process; as he said, "It seemed that one ought to be able to carry less than a pack-horse load." When he read in *The British Journal of Photography* of Bennett's method of 'ripening' gelatin emulsions, Eastman decided to try out the new process. He was so successful that he decided to go into business as a dry-plate manufacturer, using a plate-coating machine he devised and patented in 1879. His first commercial dry plates were sold in 1880, through E. & H. T. Anthony, the leading American photographic supply house. In 1881 the Eastman Dry Plate Company was formed and Eastman left the bank to work full time in his new venture. After surviving early setbacks the business prospered and he began to look for ways of simplifying photography. One of the major difficulties was the manipulation of the heavy, bulky and fragile glass plate; for the tourist, the weight of a number of plates could be an intolerable burden. Using the gelatin emulsion, Eastman coated a paper negative material which, after development, was made translucent by waxing, as in the earlier Calotype process. He also recommended treatment with hot castor oil. Unlike earlier paper processes, the new material was very sensitive and was sold in sheet sizes suitable for most plate cameras, in which it was used with appropriate adaptors. In 1884 William H. Walker, a camera maker, joined Eastman's organization, and together they developed a rollholder suitable for attachment to any standard plate camera. It took a roll of paper nega

ive material which was wound on after each exposure by turning a key, an audible signal indicating when enough had been wound. Twenty-four exposures could be made on a single roll.

There had been earlier attempts to use paper rolls in the camera, one of the earliest patented in England in 1854 by J. B. Spencer and A. J. Melhuish. Their device used sheets of Calotype paper gummed together and wound on rollers; it did not come into general use. L. Warnecke's roller slide of 1875 was more successful, carrying a 100-exposure length of paper coated with a dry-collodion sensitive surface. Although the apparatus was quite sound mechanically, the sensitive material was not satisfactory and no great use was made of the system. The Eastman-Walker rollholder, well made and with paper negative film of consistent quality, was immediately successful when it was launched in 1885. Soon after, an improved negative material was introduced under the name 'American Film'. A gelatin emulsion was coated upon a layer of soluble gelatin, which had been coated on a paper base. The paper provided a firm and flexible support for the emulsion during exposure and development of the negative. After soaking the processed 'film' in warm water the image could be stripped from the paper base, and in a series of operations it was transferred to glass or gelatin sheets for subsequent printing in the normal way. The new 'stripping' film combined the advantages of the lightness and convenience of paper during exposure with the transparency of glass during printing.

The combination of the lightweight sensitive material and the efficient rollholding mechanism was eagerly adopted by many photographers but Eastman was still not satisfied. He felt that photography was still too complicated; not only the exposing but also the processing and printing had to be carried out by the photographer, involving skills and resources not possessed by everyone. Although some 'detective' cameras were reasonably compact, the majority of cameras were bulky and inconvenient. He decided to construct a camera which would be small and simple to use, embodying the rollholder principle. His first efforts resulted in a joint patent with F. M. Cossett, in 1886, for a 'Detective Camera'. It was of box form, accepting either a plateholder or Eastman-Walker rollholder. Designed for hand use, it had an ingenious internal shutter. An example was shown at the St Louis Photographic Convention in June 1886; by the following year 50 had been

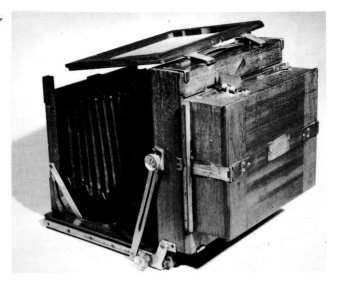

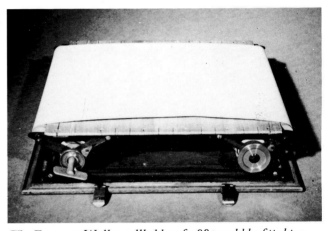

The Eastman-Walker rollholder of 1885 could be fitted to a conventional plate camera and carried a roll of paper negative sufficient for 24 exposures

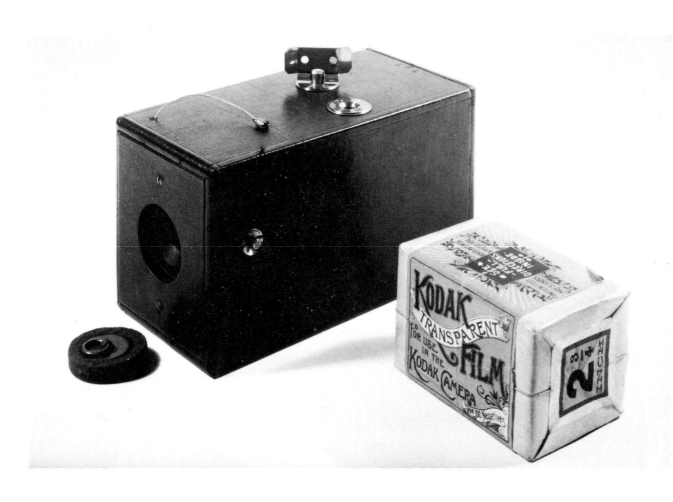

The first Kodak camera, 1888, with the celluloid roll-film created for it

made, but Eastman decided against making more. The construction was too complicated and thus the cost was too high. In 1888 Eastman sold a job lot of 40 to a dealer for sale at $50 each he turned to a new design. Patented in March 1888, the new camera was again of box form with an integral rollholder. It was small – three and three-quarter inches high, three and a quarter inches wide and six and a half inches long – easily held in the hand. The rollholding mechanism took a roll of stripping film long enough for 100 circular exposures two and a half inches in diameter. An ingenious cylindrical shutter was cocked by pulling a string, and fired by pressing a button. The 'film' was wound on by turning a key, a rotating indicator showing when enough had been wound on.

To launch the new camera Eastman invented the trade-mark 'Kodak' – distinctive, not readily misspelt, pronounced similarly in most languages and unlike any other trade-mark. The philosophy behind the new apparatus was described by Eastman in a handbook, *The Kodak Primer*: "Will any sane man or woman (for there are thousands of lady votaries of the photographic art) maintain that the necessity of going through ten specific operations, the omission of any one

of which would irrevocably spoil the work, does not seriously detract from what would otherwise be a delightful pastime . . . The principle of the Kodak system is the separation of the work that any person whomsoever can do in making a photograph, from the work that only an expert can do . . . we furnish anybody, man woman or child, who has sufficient intelligence to point a box straight and press a button . . . with an instrument which altogether removes from the practice of photography the necessity for exceptional facilities, or, in fact, any special knowledge of the art. It can be employed without preliminary study, without a darkroom and without chemicals.'' The latter statement described the most revolutionary part of Eastman's invention. To back up the camera Eastman, for the first time, provided a complete developing and printing service. In England, through an organization established by Eastman in 1885, the Kodak camera was sold for five guineas, ready loaded with a 100-exposure stripping film. When the owner had made his hundred pictures the camera was posted back to Eastman's factory. Here the film was removed and the camera was reloaded and returned immediately to the customer. The negatives were developed and printed, and, with the card-mounted prints, returned to the customer in about 10 days. The complete service, including the new film, cost two guineas. The user no longer needed to get involved with messy chemicals, and no darkroom was needed. Although the instruction manual included full details on loading, unloading and processing of the film in the darkroom, most people preferred to return the camera to the factory. Eastman launched the camera with the now classic slogan, "You press the button, we do the rest".

The camera was easy to use, even for a beginner. By choosing a small negative size Eastman was able to employ a lens of short focal length, with a consequent greater depth of field. As a result no focusing adjustment was necessary, and everything from a few feet to the far distance was sharply recorded. Snapshots were possible only in bright sunshine but time exposures for indoor photography were possible with some manipulation of the shutter. No viewfinder was provided but sighting lines were impressed into the camera top to indicate the field of view. There was no exposure counter and since the camera held a 100-exposure film it was vital to fill in the memorandum book provided so as to keep count of the pictures taken.

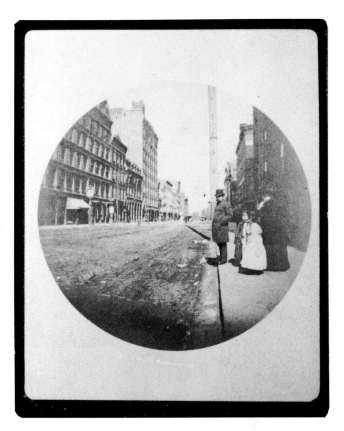

The prints from the Kodak camera negatives were returned to the customer mounted on printed cards

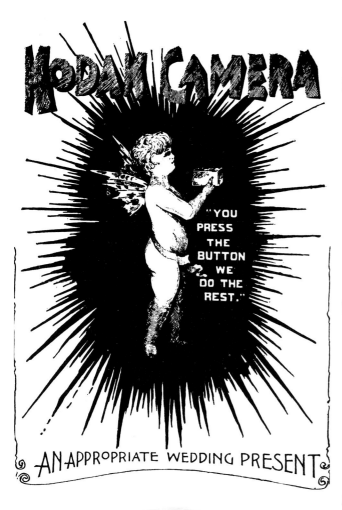

KODAK CAMERA

"YOU PRESS THE BUTTON WE DO THE REST."

AN APPROPRIATE WEDDING PRESENT

Launched in June 1888, the camera was an immediate success. People who had never before taken a photograph were able to make successful pictures. The Kodak camera was especially popular with the tourist. "It is the greatest boon on earth to the travelling man, like myself, to be able to bring home, at so small an outlay of time and money, a complete photographic memorandum of his travels," ran one early testimonial. However, Eastman was still not satisfied with the sensitive material. The stripping film involved costly and time-consuming operators. For some time Eastman had employed a chemist, Henry M. Reichenbach, to search for an acceptable substitute, as flexible as paper, as clear as glass and tougher than either. Such a material was found in celluloid – cellulose nitrate. This synthetic material was invented by the Englishman Alexander Parkes in 1861; he called it Parkesine. It was not made in a form sufficiently clear and even for photography until the 1880s. Several plate manufacturers then offered coated celluloid sheets as substitutes for glass plates, the first being sold by John Carbutt of Philadelphia in 1888. This celluloid was still rather thick and inflexible, and not easily produced in long rolls. By dissolving cellulose nitrate in alcohol Reichenbach was able to make thin sheets by pouring the 'dope' onto glass-topped tables to set. The resulting film was very thin but it was too brittle to be easily rolled. Reichenbach found that by using several additives he could produce a thin, flexible and perfectly clear film. The process was patented in April 1889 and by the summer of that year transparent celluloid films for the Kodak camera and the rollholders were in production. The film was made by 'casting' it on long plate-glass-topped tables. When set the celluloid was coated *in situ* with gelatin emulsion; when dry the film was stripped from the tables, cut to size and rolled. It was the first commercially produced transparent rollfilm.

In October 1889 an improved version of the camera was introduced with a modified shutter; it was called the Number 1 Kodak camera to distinguish it from a new and larger model, the Number 2, taking a three and a half inch circular negative. The following year five more larger versions were sold, two of them folding models, and all using the darkroom-loaded celluloid rollfilms. In an attempt to reduce the inconvenience caused by the need to load the camera in the dark, Eastman introduced in 1891 three models which could be loaded in the light. The A, B and

c Daylight Kodak cameras took a roll of cellu-loid film enclosed in a carton, with a length of black paper or cloth at the beginning and end, to protect the film from light when loading and unloading. This was an improvement, but not as much of an advance as Eastman wanted. Snap-shot photography was still not easy enough.

Above left *An early Eastman advertisement, incorporating the famous slogan*

Far left *'Out Shooting', a No. 1 Kodak camera picture by the Duchess of Bedford, c1895*

Above *'Gibraltar', a No. 1 Kodak camera picture by Furley Lewis, 1889*

55

8 The spread of popular photography

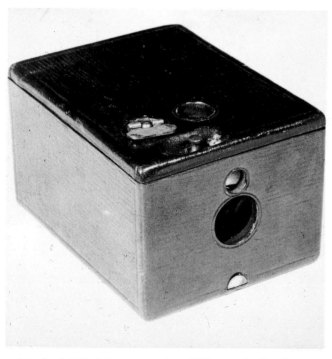

The Pocket Kodak camera, 1895. This was the first Eastman camera to incorporate the cartridge roll-film

The introduction of the Kodak cameras, supported by a developing and printing service, had brought photography to thousands who had never before attempted the process. Before snapshot photography could become really popular, however, two major disadvantages had to be overcome. First, the need to expose as many as a hundred pictures before the film could be returned for processing could lead to waste or loss of interest, and a simpler method of loading, to enable the user to load shorter films when required, was called for. Secondly, the cost was still high; the price of the first Kodak camera, five guineas, represented a considerable sum – the equivalent of over £90, or about $160, today. Eastman looked for ways of reducing the cost and complication of snapshot photography. He found the answer in a camera sold by the Boston Camera Manufacturing Company in 1892. The 'Bull's-Eye' camera incorporated an invention, patented by Samuel N. Turner, in which a length of celluloid film was attached at one end to a longer length of black paper, which protected it from light when wound on a spool. White ink numbers printed on the black backing paper could be read through a window of red or yellow celluloid in the camera back. By winding the film from number to number a precise length of film was moved on for each exposure, while the black paper provided sufficient protection for the film to be loaded and unloaded in daylight. In 1894 Eastman arranged a licence with Turner to use the 'cartridge' film system (so named for the resemblance of the rollfilm to a shotgun cartridge, and for its ease of loading). The first Kodak rollfilm camera appeared in 1895. It was a tiny box camera, two and seven-eighths inches wide by two and a quarter inches

high by three and seven-eighths inches long, taking pictures one and a half inches by two inches on a 12-exposure rollfilm. It was called the Pocket Kodak camera and mass-production techniques applied to its simple design enabled Eastman to sell it for one guinea. Immediately it became a best-seller. Although small, the negatives were capable of enlargement and yielded high-quality prints. Eastman purchased outright Turner's title to the invention in 1895 and production began on other cameras using the cartridge rollfilm, including a new version of the 'Bull's-Eye' camera. To increase the picture size without a great increase in the overall size of the camera a new folding model was designed and introduced in the autumn of 1897. The Folding Pocket Kodak camera was the first of a range of folding cameras of a design that was to remain in use for over 60 years. To cater for the more experienced photographer, in 1897 Eastman also introduced the first of a range of larger format models – the Cartridge Kodak cameras. These had a more advanced specification and in the hands of a skilled photographer were much more

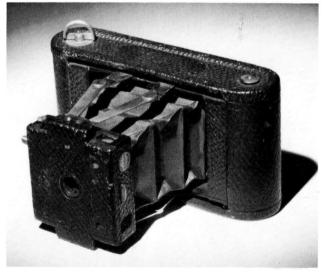

Top *A Pocket Kodak camera picture of a London flower-seller, 1896*

Above *The Folding Pocket Kodak camera, 1897*

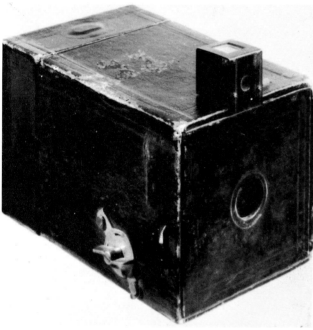

Top '*Rue Clichy, Paris*', *a Folding Pocket Kodak camera picture by George Eastman, 1897*

Above *The Brownie camera, 1900*

Right '*The Brownie Girl*'. *The Brownie camera was especially popular with children, and sold for five shillings*

versatile than the straightforward box cameras.

Eastman was still concerned about the cost of photography; although the one-guinea Pocket Kodak camera had been very popular, it was still beyond the reach of millions who wanted to take photographs. In particular, Eastman wanted a camera sufficiently inexpensive and simple to use that would be suitable for children. A new model was developed, designed by Eastman's camera maker, Frank Brownell (and, perhaps, named after him); it was first sold in 1900 as the Brownie camera. A simple box camera, it cost five shillings, and took pictures two and a quarter inches square on the cartridge rollfilm. Like the original Kodak camera it had sighting lines impressed into the top to help in aiming, although, for an extra shilling, an accessory reflecting viewfinder was available. This simple camera and the family of cameras which evolved from it were the introduction to photography for millions throughout the world, including many men and women who became leading photographers of this century.

The popularization of photography which began in 1900 with the introduction of the Brownie camera was to be of considerable social significance. For the first time the snapshot album provided the man in the street with a permanent record of his family and its activities. The importance of this to the family is reflected in the sudden increase in sales of cameras and photographic materials during the First World War. Although the introduction of the simple camera has been criticized for having led to the production of millions of 'non-creative' images, this argument misses the point of the value of these family archives, not only to the people concerned, but also to the social historian. For the first time in history there exists an authentic visual record of the appearance and activities of the common man made without interpretation or bias.

The great success of the simple rollfilm camera had a considerable influence on the development of other branches of photography. Although the plate camera was to remain in popular use for the first quarter of this century, more and more photographers turned to rollfilm cameras and a great variety of makes and models became available. Plate camera makers attempted to compete by developing box cameras carrying a dozen or more plates preloaded in the darkroom but by comparison with their rollfilm counterparts these magazine plate cameras were heavy and cumbersome. The rapidly growing market

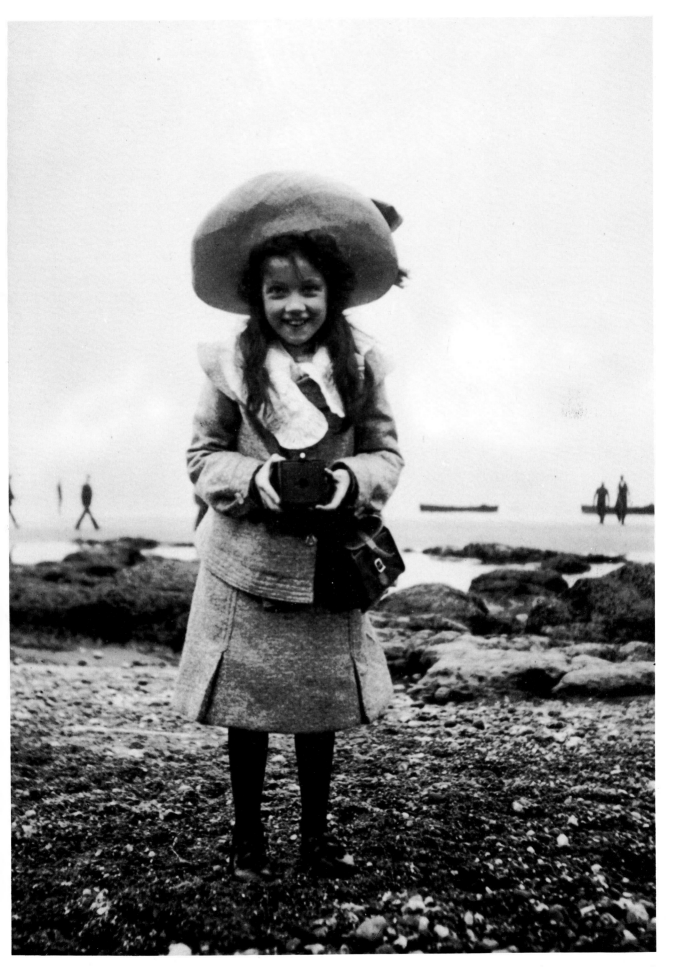

The Dubroni camera, 1864, in which the wet plate was sensitized, exposed and developed within the camera, by chemicals introduced through the aperture at the top

for photographic goods encouraged the development of new apparatus and materials and photographic manufacture changed from a cottage industry to one of mass-production in a matter of a few years.

By 1900 the basis of modern photography had been established; there has been no fundamental change in the chemistry of the process since the gelatin dry plate was introduced. As yet no materials as sensitive or as versatile as the salts of silver have been found, despite continuous research. Of course, photographic materials have greatly improved; rollfilms are available today with almost 300 times the sensitivity of Eastman's first celluloid rollfilm. Improvements in the quality of the sensitive material permit the use today of very small negatives capable of great enlargement. In 1900 any camera taking negatives less than four and three-quarter inches by six and a half inches was considered to be something of a miniature. That is over 72 times the area of the pictures produced in today's pocket cameras. The fundamental principles of colour photography had been proposed and demonstrated by the turn of the century, following the demonstration of the first colour photograph by James Clerk Maxwell in 1861; several methods of producing colour transparencies and colour prints were in use. But all needed considerable manipulation, skill and experience; the era of the simple colour snapshot was more than a generation away.

Although in the last 70 years cameras have become increasingly versatile and compact, few incorporate basic features which were not in existence or at least foreshadowed at the beginning of the century. There would appear to be a departure from traditional methods in the recent application of electronics to camera shutter design but even here the complex circuitry is performing tasks similar to those carried out in the past by gears, springs and levers. New glasses have significantly improved lens quality in recent years but many modern camera lenses are based on designs first proposed in the last century. Even the modern 'instant picture' cameras have their counterparts, albeit primitive ones, in a number of cameras in use in the middle of the last century, in which all the chemical operations of sensitizing and processing were carried out inside the camera.

The first practical motion pictures, inspired by the pioneer work of Muybridge and Marey and made possible by the introduction of Eastman's transparent celluloid film in 1889 were publicly

shown in 1893 in Edison's Kinetoscope viewing machine; by the end of 1895 the Lumière brothers of Lyons were projecting moving pictures to paying audiences. Within a year cinematography was practised throughout the world. Recorded sound combined with the moving picture had been demonstrated by Edison in America in 1896; the first colour motion picture followed only 10 years later.

The evolution of photography from the first shadowy, impermanent images made by Wedgwood to the introduction of the simple camera within the reach of all took almost exactly 100 years. During that time photographers, often coping with inadequate materials and imperfect apparatus, produced some of the finest photographs ever made. Their surviving images illustrate the evolution of creative photography that accompanied the technical development of the photographic process.

Left *The Lumière Cinematographe – a combined cine-camera, projector and printer, 1896. The first public shows of projected films were given by a prototype of this machine in 1895*

Right '*The Soldier's Courtship', from an early cine-film by R. W. Paul, 1897*

9 'Likenesses produced in a few seconds...'

If the reader finds a Victorian photograph among the family archives it will almost certainly be a portrait. The making of likenesses was a major application of photography from its very beginning. The Daguerreotype competed directly and effectively with the miniature painting; the camera recorded in a few moments an image more detailed than that produced by hours of work by the artist. The finished image was often delicately hand coloured and mounted in a case similar to that employed for miniature paintings. Portraiture by the Daguerreotype process was not really practical until improvements in 1840 reduced the exposure times from minutes to seconds and only a few portraits survive from the earliest period. One of the most notable is that of Miss Dorothy Draper, taken by her brother, Dr Draper of New York, in the summer of 1840. The first English licensee of Daguerre was Antoine François Claudet, who began making and selling Daguerreotypes in London in 1840. As well as becoming a leading Daguerreotypist, Claudet made a number of important contributions to the development of photography. The first commercial portrait studio in Great Britain was opened by Richard Beard, a London coal merchant, as a speculative venture, having engaged John Goddard to operate and improve the process. After opening in March 1841, Beard made a considerable sum of money from his business and from the sale of licence rights to photographers in the provinces. He lost most of his money later in litigation to protect his monopoly, which in any case ceased with the expiry of Daguerre's patent in 1853.

Apart from Claudet and Beard the principal Daguerreotypists in London were W. E. Kilburn and John Jabez Mayall, an American, who had come from Philadelphia in 1846, where he had practised Daguerreotypy under the name 'Professor Highschool'. The work of both photographers was of a consistently high standard. Claudet's assistant, T. R. Williams, joined the small number of portrait photographers in London around 1850. After 1853 many English photographers, known and unknown, used the Daguerreotype process for a few years. Some of their work is of fine quality. In America, free from patent restriction, the Daguerreotype was extensively used for a longer period than in Britain. Mathew Brady, whose later photographs of the American Civil War are famous, began as a portrait Daguerreotypist.

The Calotype process was little used for professional portraiture, although many of Talbot's early pictures were of people. The miniature painter, Henry Collen, and Antoine Claudet took licences from Talbot to operate the Calotype process for professional portraiture, but neither had much commercial success with it. Others, such as Henri Victor Regnault of Sèvres, used the process primarily for landscape work, but recorded their friends and acquaintances on paper negatives. The most notable Calotype portraits were made by two Scotsmen, David Octavius Hill and Robert Adamson. In 1843 Hill, a painter, was inspired by the Act of Demission whereby the Free Church of Scotland was established, to produce a major composite painting showing all the delegates assembled. Hill decided that photography was the only method by which portrait sketches could be obtained of the hundreds of ministers. Robert Adamson had learned and was practising the Calotype process in Edinburgh; Hill joined him

in a fruitful partnership which lasted until Adamson's early death in 1848. They produced some of the finest portraits in the history of photography, their sitters ranging from the 'quality' of Edinburgh to the humble fisherfolk of Newhaven.

In the 1850s, as a result of the introduction of the wet-collodion process, there was a dramatic increase in the number of portrait photographers, accompanied by a decline in the average quality of the photographic portrait. Many of the new photographers mastered the manipulations required but few had the creative talent of the masters of the Daguerreotype, some of whom turned to the new process with equal success. With the introduction by Disderi of the carte de visite photograph the flood of portraits became a torrent. Camille Silvy, a diplomat turned photographer, was perhaps the most notable of the exponents of the new photography in England, though some of the old hands like Mayall turned their talents with the Daguerreotype to superior carte de visite photography. Mayall's photographs of the English Royal family helped to start the craze for carte de visite collecting. The majority of carte portraits were, however, routine and uninspired, in striking contrast to the portraits of Mrs Julia Margaret Cameron. Coming to photography in middle age, she became obsessed with the medium and from 1864 pressed her famous friends from the worlds of literature, arts and sciences to sit for her. She used large wet-collodion plates, often imperfectly coated and processed, but nevertheless she managed to capture penetrating character studies of her 'victims'. Only Nadar, the Parisian photographer, produced work of comparable power. He and Mrs Cameron are today regarded as the giants in portraiture in the second half of the 19th century.

The relative simplicity of many early portrait studio settings gradually gave way to more elaborate and ornate studio furniture and backgrounds, as the following gallery shows. Sometimes sitters dressed in costume for their portraits. The rich man might dress as a humble artisan, the provincial lady as an eastern beauty. Such grand productions were far removed from the sixpenny likenesses of the backstreet photographers of the 1850s.

63

The miniature painting took the artist many hours to produce.

The Daguerreotype photographer could produce a comparable likeness in a few minutes

Daguerreotype by Antoine Claudet, c1854

One of the earliest Daguerreotype portraits, made by Dr Draper in the summer of 1840, of his sister Dorothy

Daguerreotype by W. E. Kilburn, c1850

Vincent Potter, Daguerreotype by Richard Beard, c1848

Daguerreotype of a boy, photographer unknown, c1856

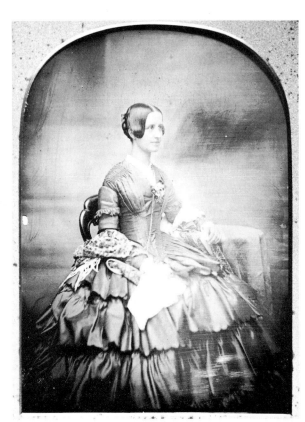

Daguerreotype of a young lady, photographer unknown, c1850

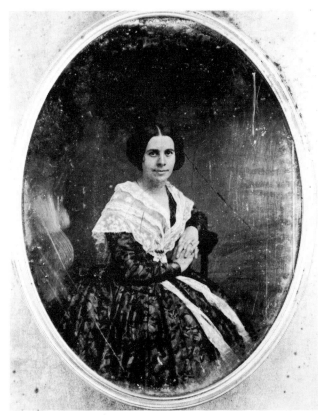

Daguerreotype of Jenny Lind, by Mathew Brady, c1850

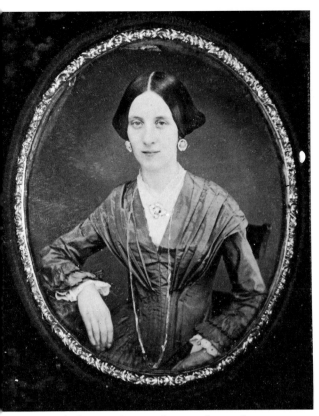

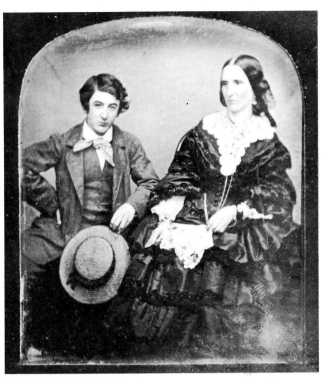

Daguerreotype by an unknown photographer, c1852

Daguerreotype of a mother and son, by J. Mayall, 1852

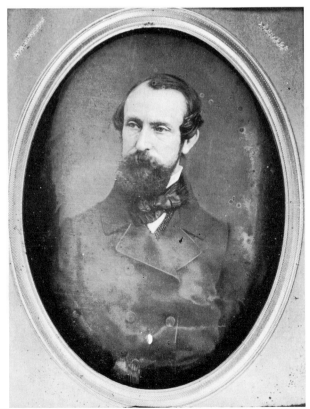

Daguerreotype portrait of a gentleman, by Jeremiah Gurney of New York, c1850

Daguerreotype of a judge, by T. R. Williams, c1855

Calotype self-portrait by Antoine Claudet, c1844

J. Grahame, Master of the Mint, a Calotype by H. V. Regnault, c1850

Mrs Constance Talbot and Ela, Rosamund and Matilda, Talbot's daughters – a Calotype photograph, 19 April 1842

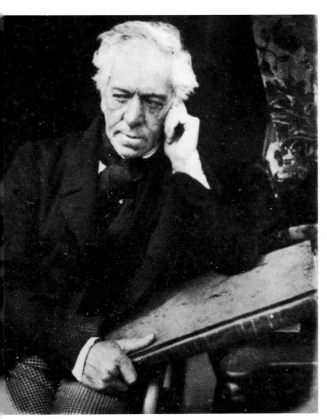

Sir William Allan, a calotype by D. O. Hill and Robert
Adamson, c1844

'Asleep – Misses Farney and Brownie', Calotype by D. O.
Hill and Robert Adamson, c1844

'Three Fishwives', Calotype by D. O. Hill and Robert
Adamson, c1844

Collodion positive of a mother and child, by W. E. Kilburn, c1856

Portrait of two ladies, from a stereo collodion positive, photographer unknown, c1858

A lady and gentleman at their door, an albumen print by an unknown photographer, c1860

*Flo, Connie and Laura Bainbridge, 1861, an albumen print
by an unknown photographer*

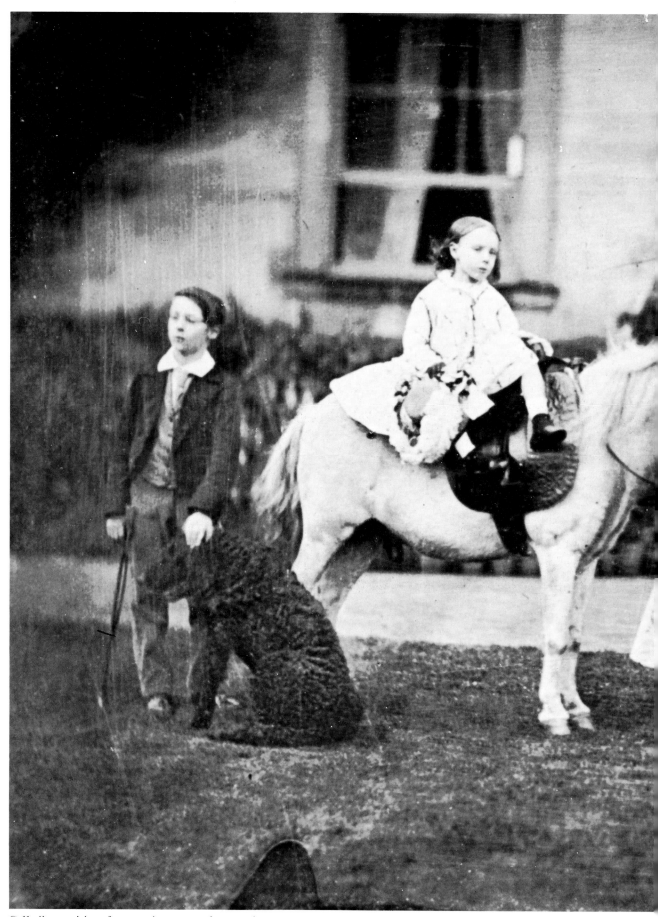

Collodion positive of an exterior group, photographer unknown, c1860

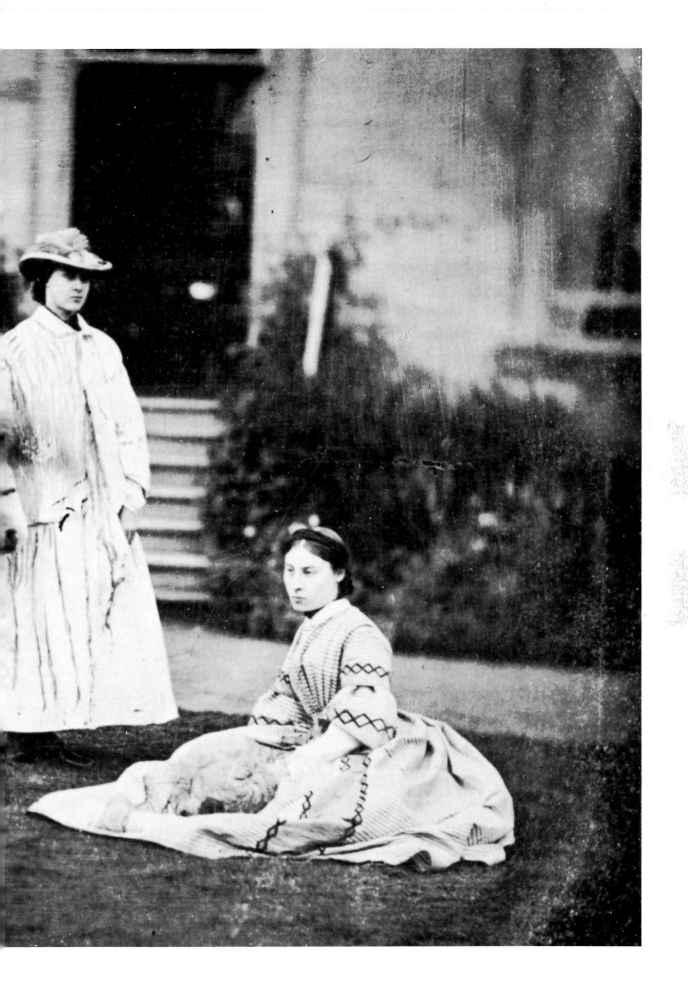

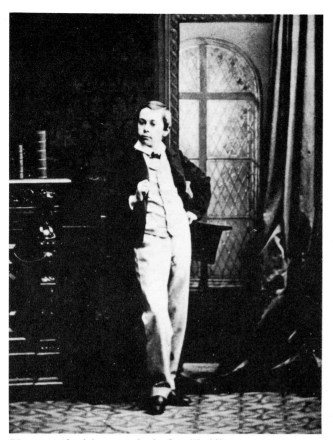

Two carte de visite portraits by Camille Silvy, c1865

The usual, somewhat formal pose has given way to a more intimate arrangement in these cartes of married couples

74

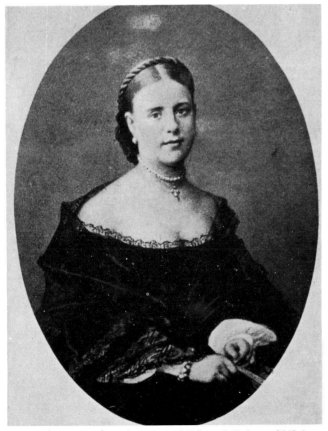

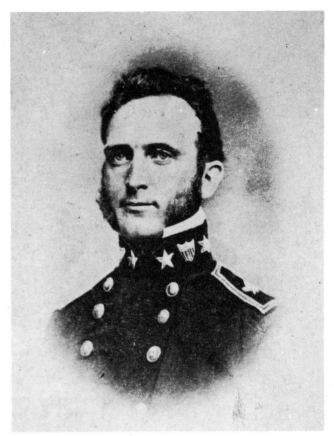

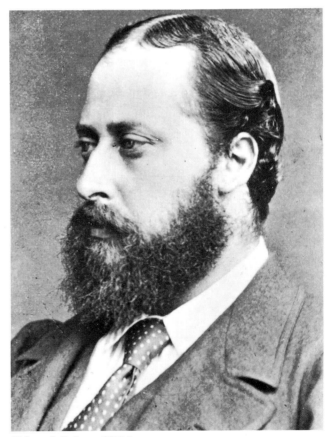

Charles Dickens

General 'Stonewall' Jackson

Mrs 'Skittles' Walters, mistress of Edward, Prince of Wales

Edward, Prince of Wales

Rachel and Laura Gurney, by Mrs Julia Margaret Cameron

George Sand, the novelist, a portrait by Nadar, 1864

Sir Henry Taylor, by Mrs Julia Margaret Cameron

The basketmaker', c1865, photographer unknown

Costume portrait by James Arthur, 1898

10 Record and reality

The limitations of the early photographic processes confined their use to those subjects where rapid movement and change were absent. The small proportion of Daguerreotypes showing exterior scenes rarely include people or vehicles in the streets since only those standing still for the many seconds of the exposure would be recorded. For portraiture the sitter needed supports for head and limbs during the long exposure, a practice that persisted throughout the Victorian period. The majority of architectural and landscape pictures from the first decade of photography are Calotypes, the process being especially suitable for these subjects, and convenient for the travelling photographer. Talbot's early photographs include scenes in France, as well as many of London, Scotland, Oxford and elsewhere in the British Isles. Friends of Talbot, the Reverend George Bridges and the Reverend Calvert Jones, employed the Calotype process to record their travels in the Mediterranean in the late 1840s. The improved sharpness and keeping properties of the waxed paper process were exploited by photographers of architecture like Dr Thomas Keith of Edinburgh and Samuel Smith of Wisbech, Cambridgeshire. Smith pioneered the use of systematic photographic recording to document changes in his home town. Other landscape photographers who employed the paper negative process with great success were James Mudd of Manchester and H. V. Regnault.

Despite the complex manipulations involved, the sensitivity of the wet-collodion process made it possible to record more directly events as they occurred. Roger Fenton, a landscape photographer, adopted the new process to make dramatic records in the Crimea during the war in 1855. Although his pictures were of necessity posed, and away from the centre of battle, their authenticity brought home a glimpse of life at the seat of war. James Robertson followed Fenton to the Crimea and made striking records of the aftermath of the battles at Sebastopol. Mathew Brady and his assistants, notably Alexander Gardner, made a comprehensive photographic record of the American Civil War and the personalities involved in it. From this time on the records of the war correspondent and artist were supplemented increasingly by the work of the photographer. For example, James Burke accompanied the English troops during the Afghan wars of 1878–9, making fine-quality pictures of the bleak landscapes and the combatants, on both sides, who fought their way through them.

The quality and easy reproduction the collodion process made possible enabled photographers to satisfy the growing demand for pictures of the world – souvenirs for the traveller and glimpses of the wonders of the world for those who stayed at home. Francis Frith, an English landscape photographer, was one of the first commercial photographers to specialize in such pictures. He began in 1856 with a tour of the classical archaeological sites in the Near East; in time his photographic activities covered much of Europe. He set up an organization of photographers and printers to keep pace with the demand for pictures; by the turn of the century the Frith company had turned to picture postcards. The Frith postcards covered almost every inch of the British Isles and the business he founded survived until only a few years ago. Other commercial landscape and architectural photographers in England include

Francis Bedford, W. R. Sedgfield and William England, and in Scotland James Valentine of Dundee. George Washington Wilson of Aberdeen produced thousands of commercial stereoscopic photographs ranging from pioneer action pictures to Scottish landscapes of rare beauty. Instantaneous photography, fully practical with the advent of the gelatin dry plate, made it possible to record events as they happened, without posing or arrangement. In the 1890s Paul Martin, a London engraver-turned-photographer, was a pioneer of what later became known as 'candid' photography, using a disguised camera to capture the people of London in the streets and at the seaside.

The simplicity and portability of the early rollfilm cameras led to their use on many journeys of exploration. The most dramatic examples of such expedition photographs are, perhaps, those taken on the ill-fated attempt in 1897 by Salomon Andrée to reach the North Pole by balloon. Thirty-three years after the crash of the balloon in the Arctic and the subsequent death of Andrée and his companions, the films were discovered in the ice. When developed they revealed astonishing images of the tragic expedition. The rollfilm camera enabled the humble amateur to record dramatic events. From the 1890s such pictures supplement those of the press photographer; indeed it is not unknown for the professional to be 'scooped' by a beginner who just happened to be standing in the right place at the right time with his camera.

The selection of pictures on the following pages illustrates the development in exterior photography that took place during the second half of the 19th century.

Above left *The River Seine, Paris, Daguerreotype, 1845*

Far left *Daguerreotype of a river scene, India, c1848.*

Centre left *A street in Cork, Daguerreotype, c1850*

Above *The Capitol, Washington, from the east. A Daguerreotype probably by John Plumb Jr, 1846*

Left *Sir Walter Scott's Monument, Edinburgh, in course of building. A Calotype by W. H. F. Talbot, October 1844*

Top left, 'Orleans', June 1843, Calotype by W. H. F. Talbot

Centre left *Malta, c1850, a Calotype by the Reverend Calvert Jones*

Left *Taormina, c1851, a Calotype by the Reverend George Bridges*

Above *Edinburgh Castle, from the Grassmarket, from a waxed paper negative by Dr Thomas Keith, c1856*

Above left *Cornhill, Wisbech, Cambridgeshire, 1854, from a waxed paper negative by Samuel Smith*

Far left *Caernarvon Castle, from a waxed paper negative by James Mudd, c1855*

Above *The River Nene, Wisbech, Cambridgeshire, 1862, from a waxed paper negative by Samuel Smith*

Left *Caernarvon Castle, c1860, by Francis Bedford*

Top left '*The Valley of Death*', a Crimean War photograph by Roger Fenton, *1855*

Centre left *The camp of the 4th Dragoon Guards, a Crimean War photograph by Roger Fenton, 1855*

Far left *Malakoff, from the Mamelon Vert, a Crimean War photograph by James Robertson, 1855*

Above *Rebel caisson destroyed by Federal shells, Fredericksburg, Va, 3 May 1863, an American Civil War photograph by Mathew Brady*

Left *Guns captured at Ali Musjid, Afghan War, 1878–9, photographed by James Burke*

Above *The Old House in the Close, Exeter, c1859, by W. R. Sedgfield*

Above right *Sèvres, a Calotype by H. V. Regnault, c1850*

Right *The Great Pillars, Baalbek, by Francis Frith, 1856*

View of the Sphinx and the Great Pyramid at Giza, from a
stereo-photograph by Francis Frith, 1856

Above *York Minster, by G. W. Wilson, c1860*

Right *James Nasmyth and his steam hammer, 1855, probably by J. Sidebotham*

Below right *The Broad Sanctuary in construction, Westminster, 1854. Note the unfinished Palace of Westminster in the background, left. From a stereo-transparency by an unknown photographer*

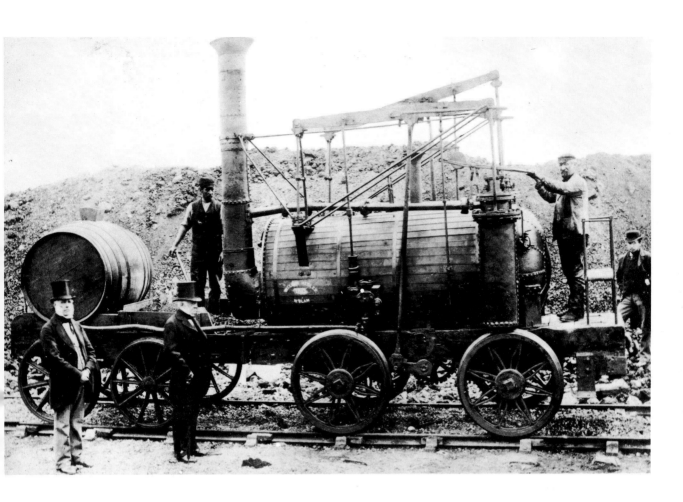

Above '*Wylam Willey*' *by R. H. Bleasdale, c1856*

Left The Great Eastern *in Southampton Water, c1860, by G. W. Wilson*

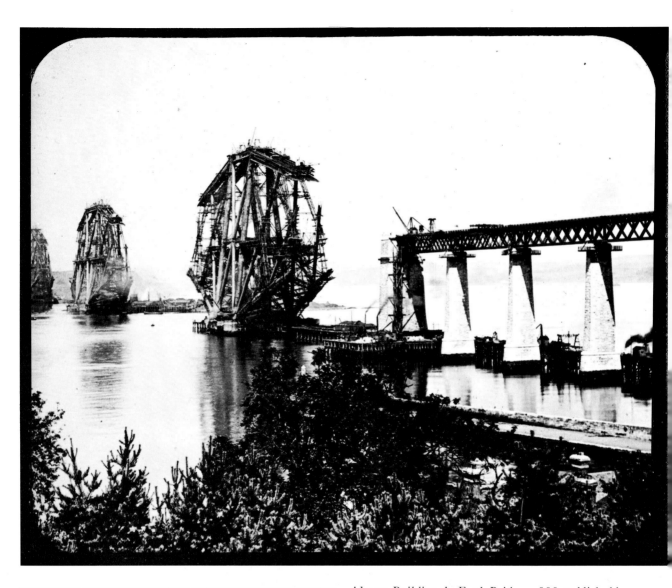

Above *Building the Forth Bridge, 1888, published by G. W. Wilson*

Left *The Oxford and Cambridge Boat Race, 1884, by F. C. L. Wratten*

Above right *The Andrée balloon, wrecked on the Polar ice, 1897, by Salomon Andrée*

Right *Train accident, Paris, c1896, by an unknown amateur photographer with a Pocket Kodak camera*

Above left *Fire in Oxford Street, London, 1897, by George Davison*

Left *Hansom cab accident, c1895, photographer unknown*

Above *Hampstead Heath, 1898, by Paul Martin*

Right *Trades Union march, Brighton, c1896, by an unknown amateur photographer*

11 Depth and decoration

One of the most popular photographic novelties displayed at the Great Exhibition of 1851 in the Crystal Palace in London was the stereoscopic photograph. The slightly dissimilar viewpoints provided by our two eyes are combined in the brain to give an image in depth. If two photographs of a scene are taken from points of view separated by about two and a half inches, and are then viewed so that each eye receives only the image appropriate to it, the result is an apparently three-dimensional picture. The principle was first described by Sir Charles Wheatstone in 1832; he later devised a viewer using mirrors by which pairs of pictures could be viewed, but it was not until Sir David Brewster introduced in 1849 an improved device using lenses that the stereoscope became really practical. Following the interest aroused at the Great Exhibition, a craze for stereophotographs developed which lasted for 20 years, with periodic revivals of interest ever since, notably around 1900. Large editions of some stereoscopic subjects were sold, travel scenes being especially popular. Stereoscopes for viewing the cards ranged from simple hand models to table or column viewers holding hundreds of stereo photographs carried on endless belts behind the viewing lenses.

An important application of Victorian photography was its use for personal or domestic decoration. Photographs were incorporated in jewellery – Daguerreotypes, collodion positives and albumen prints were mounted in brooches, lockets and pendants. Tiny photographs were set in rings, tie-pins and cuff-links. Frequently the photograph was accompanied by a lock of hair and an inscription in memory of a dead loved one. A variety of special printing processes developed in the 1850s and 1860s made it possible to transfer photographic images to china glass and enamelled surfaces, the pictures then being fixed into the surface glaze. Drinking glasses, plates, vases, tiles and enamelled plaques were among domestic items decorated in this way. Such pictures are absolutely permanent and can be destroyed only by breaking.

The wet-collodion process was capable of recording exceptionally fine detail, and this property made possible the production of micro photographs – pictures reduced to microscopic size. The technique was pioneered in Manchester by John Benjamin Dancer. From 1853 he produced a series of microscope slides bearing images smaller than a pin's head. When highly magnified, fully detailed portraits, art reproductions or texts were revealed. Around 1860 it became fashionable to have such microphotographs incorporated into items of jewellery or souvenir trinkets, with a built-in Stanhope lens which revealed the details of the image when held to the eye. The techniques of microphotography had a dramatic application during the siege of Paris in the Franco-Prussian war of 1870–1. Printed messages, dispatches and news information were photographically reduced onto small collodion 'pellicles' which were rolled and inserted into a quill container attached to a carrier pigeon. The birds flew over the enemy lines and on receipt the messages were projected by magic lantern onto a screen and the contents written down for onward transmission.

Some time after its introduction photography was applied to the illustration of books. The first book illustrations derived from photographs were produced by using Daguerreotypes as guides to the hand engraving of the printing plate. The Parisian optician N. P. Lerebour

published a fine series of aquatint engravings between 1840 and 1844, under the title *Excursions Daguerriennes*. Although hand-engraved they look very realistic since the original Daguerreotypes have been closely followed by the engraver, who added human figures. Later, albumen prints were similarly used as guides to the engraver. An alternative was to use original paper prints by the Calotype and, later, albumen printing processes, pasted directly into the book. The first published work of this type was Talbot's *The Pencil of Nature*, published from 1844 to 1846. However, Calotype prints were subsequently little used, since they were inclined, through faulty processing and the effect of the adhesives, to be impermanent. The improved stability of the albumen print led to a wider use of photographic prints as illustrations in the 1850s, '60s and '70s.

Because of the length of time required to print the pictures in quantity and to paste them into each copy of the book, many attempts were made to devise a system for mechanically printing photographic illustrations. Hippolyte Fizeau achieved a little success by directly etching Daguerreotype plates so that copies could be printed in ink but only very short printing runs were possible. Talbot, in the early 1850s, was the first to produce a successful printing plate directly by photography. In 1855 he published his method of 'Photoglyptic engraving' which produced in an ink print an adequate rendering of the subtle tones of a photograph. Other methods of photoengraving followed but none came into general use until the 1870s, when photo-mechanical printing of long runs of illustrations replaced the earlier methods. The mechanical printing process which came closest to reproducing the tonal qualities of an original photograph was devised by Walter Woodbury of England in 1866. The Woodburytype was printed from a lead block which had been brought in contact, under extreme pressure, with a hardened gelatin relief image prepared photographically. The mould so prepared varied in depth depending upon the tonal density of the original photograph; filled with gelatinous ink it was brought into contact with dampened paper in a press where the ink transferred to the paper. When dry, the Woodburytype was trimmed and pasted into the book. The process gave a very accurate reproduction of the original photograph, and it is sometimes difficult to believe that the Woodburytype is not a real photograph. It was suitable only for short printing runs, as although the printing operation speeded up the production of the illustrations, they still had to be inserted individually. Between 1870 and 1895 many books were published with illustrations produced in this way.

Included in the following selection are examples of microphotography and stereoscopic photography, jewellery incorporating Daguerreotypes, and book illustrations produced from photographic originals.

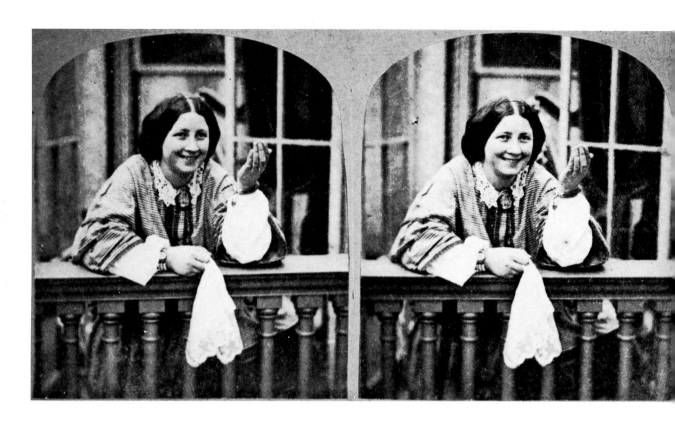

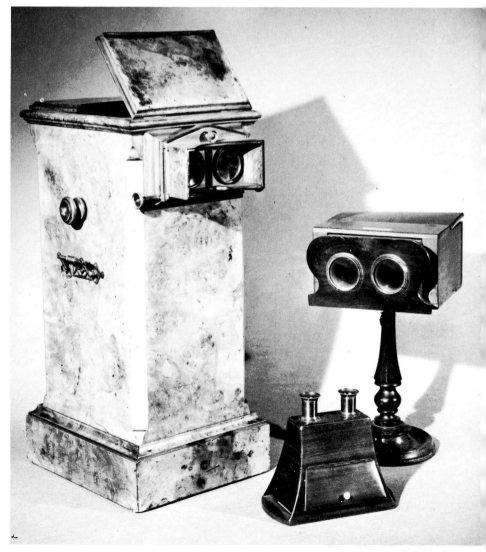

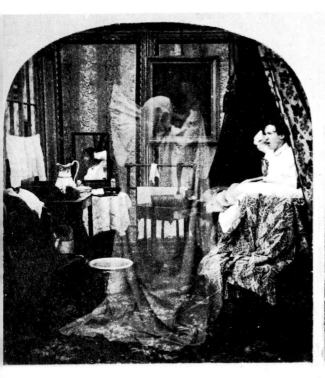
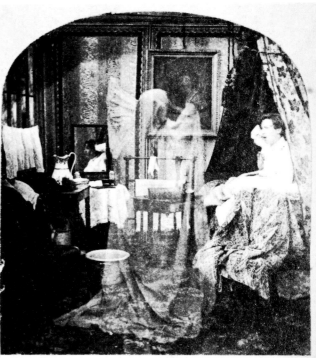

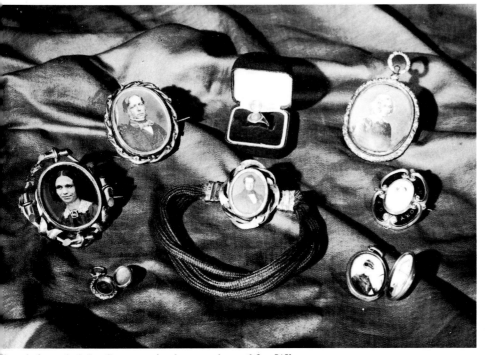

Top left and right *Stereoscopic photographs, c1860. When viewed in a stereoscope the pairs of images blend to give a picture in depth*

Left *Stereoscopes for the hand, on stands or in cabinet form or the table, were standard items in the Victorian parlour*

Above *Items of jewellery incorporating Daguerreotypes, collodion positives or albumen prints, 1850–70*

'*Ariadne*', *a microphotograph* (*actual size*) *by J. B. Dancer,
with an enlargement of the image*

Top *A pellicle of the type used for the Paris pigeon post, 1871* left, *with an enlarged detail* right

Left *Photographs transferred to china, glass, ceramic tile and enamelled metal*

Above *Souvenir trinkets containing Stanhope lenses with microphotographs*

Top *Print from an etched Daguerreotype plate, by Hippolyte Fizeau, 1842*

Above *The Great Mosque at Algiers, an engraving from* Excursions Daguerriennes, *c1841*

Right *Wisbech parish church, a Calotype by Samuel Smith, with an engraving derived from it for the* Wisbech Advertiser. *Note that the engraver has added figures*

Top *Woodburytype illustration from* Pictorial Effects in Photography, *1869, by H. P. Robinson*

Above *Etched steel plate print by Talbot, 1852. An improvement in this process led to the first effective photo-engraving method, photoglyptic engraving, in 1855*

12 'Art' photography and pictorialism

In the early years of photography the ability to record images directly from nature was novelty enough. The photographer was content to record what was there, choosing a suitable angle, distance and, perhaps, time of day. Occasionally, as in Talbot's picture 'The Open Door', the photographer would manipulate some elements of the scene to create a pleasing composition. Essentially, however, the early photographs were made of and from nature. This natural pictorial approach can be seen at its best in many of the commercial photographs of such British photographers as G. W. Wilson and in the later work of amateurs such as Lt Colonel John Gale, a leading pictorial photographer in the 1880s.

Victorian photographers soon began to develop an imitative style reproducing the currently fashionable or classical styles of painting, many photographs being of still-life compositions. Even nude photographs were available, with poses in the styles of painters like Courbet or Ingres. In the 1850s, a new 'art' movement was led by several painter-photographers, notably the water-colourist William Lake Price. A technique of printing more than one negative onto a single sheet of paper had been used by Calotypists to add clouds to otherwise featureless skies. This technique became much more practical with the glass collodion negative, and combination printing was used by Lake Price and other 'High Art' photographers to construct elaborate compositions. The most famous exponent of this technique was the Swedish portrait painter Oscar G. Rejlander. Living in England, in 1853 he turned to photography, and in 1857 created a huge allegorical picture called 'The Two Ways of Life'. Thirty negatives of figures were printed onto two sheets of photo-graphic paper, together with several backgrounds. When joined, the picture measured 31 inches by 16 inches. This combination print had considerable influence on Rejlander's contemporaries, especially after it was purchased by Queen Victoria.

Henry Peach Robinson, an English amateur painter, became a professional photographer in 1857. Greatly influenced by Rejlander's work, Robinson produced many combination prints, a typical example being 'When Day's Work is Done', made in 1877 from six negatives. Although the improvements in photographic materials that came with the gelatin dry-plate process largely removed the need for combination printing, Robinson continued to use it for some of his later pictures. However, most of his later work shows carefully posed figures in rural settings. Each picture was carefully planned, with Robinson's friends dressing up in character, rehearsing the pose until everything was right. Although his techniques of picture *making* instead of picture *taking* often produced attractive images, to the modern viewer many are excessively theatrical in effect.

Mrs Julia Margaret Cameron was also strongly influenced by classical art, and many of her compositions are pictorial allegories in the style of Renaissance paintings. The poses in a number of her portraits are based upon works of the Masters of painting and frequently have religious themes or titles.

These attempts to make 'High Art' of photography were rarely successful. Photography was confined by being made to imitate painting, instead of being allowed to develop in its own right. After the extravagances of the 'art' photography of the 1860s and 1870s, creative photography

went into decline for some years, due, perhaps, to a preoccupation with the changing technology introduced by the gelatin dry plate. The new process greatly simplified the business of taking a photograph, and perhaps as a result a new style of 'naturalistic' photography developed, promoted by Dr Peter Emerson. In his book *Naturalistic Photography*, published in England in 1889, Emerson claimed that through careful choice of viewpoint, subject and lighting, and above all selective focusing, the photographer could produce work of a high creative quality without resorting to the manipulations and artificial techniques used earlier. Emerson, American-born but living in England, demonstrated his theory in beautiful photographs of the landscape and countryfolk of Norfolk, published in a series of illustrated books and portfolios. A number of amateur photographers took up Emerson's principles with enthusiasm. Notable among them was George Davison. After examining closely the work of the Impressionist painters Davison experimented with methods of creating soft focus images, sometimes using a pinhole instead of a lens to form a diffuse image on the plate, and exploited new printing processes such as the use of gum bichromate for the control they gave over the quality of the image. Davison's growing reputation led to a clash with Emerson who, in 1890, repudiated his former belief in naturalistic photography. In 1892 a number of the pictorial photographers of the naturalistic movement broke away from the traditional photographers, whose work was typified by that exhibited at the exhibitions of the Royal Photographic Society (founded as The Photographic Society of London in 1853). Led by George Davison, they formed 'The Linked Ring', dedicated to the promotion of photographic pictorialism. Among those active in the group until its dissolution in 1909 were J. Craig Annan (who had pioneered photogravure printing in Great Britain), Eustace Calland, A. Horsley Hinton, Paul Martin and Frank M. Sutcliffe. Sutcliffe, a professional photographer of Whitby in Yorkshire, managed, although working with a stand camera, to produce pictures of the inhabitants and environs of Whitby, notable for their fresh and informal effect. He took eagerly to the new hand cameras and from 1898 to around 1906 George Davison, at that time managing director of Kodak Limited, supplied him with the latest models for evaluation.

In America a similar reaction against the photographic establishment occurred, and The Photo Secession was formed in 1902. Led by Alfred Stieglitz, the group, like The Linked Ring, was devoted to the new pictorialism and numbered among its prominent members Alvin Langdon Coburn, Edward Steichen, Gertrude Kasebier and Annie W. Brigman. The attitude of the new photographers was summarized in the annual *Photograms of the Year* for 1900: "That wealth of trivial detail which was admired in photography's early days and which is still loved by the great general public whose best praise of a photogram is that it is 'so clear', has gone out of fashion with advanced workers on both sides of the Atlantic". Their techniques involved considerable handwork on the print and use of special printing processes, such as photogravure and the use of gum bichromate which gave a softening of line and suppression of detail – the 'practical effect' for which they strived. Their work gained general acceptance in the art world, both in Europe and America.

Top left *Statuary still-life, by Hippolyte Bayard, c1840*

Top right *Still-life Daguerreotype by Carpenter and Westley, c1853; note the reflection of the daylight studio roof in the glass dome*

Above *The Open Door, a Calotype by W. H. F. Talbot, c1844*

Right *A Yard at Sèvres, a Calotype by H.V. Regnault, c1851*

Still life by T. R. Williams, c1855

Nude, Daguerreotype by an unknown photographer, c1854

Top '*A Misty Morning, Rydale*', *c1860, from a stereo-photograph by Thomas Ogle*

Above '*The Loch of Park, at Sunset*', *c1858, from a stereo-photograph by G. W. Wilson*

'Sleepy Hollow', by Lt Colonel J. Gale, 1888

Above '*Disgust*', *a self-portrait by Oscar G. Rejlander, from Darwin's* Expressions of the Emotions, *1872*

Top '*Don Quixote in his Studio*', *1855, from a stereo-photograph by W. Lake Price*

Above '*The Wayfarer*', *a combination print from four negatives, by Oscar G. Rejlander, 1857*

Right '*Ploughing Scene*', *by George Davison, c1888*

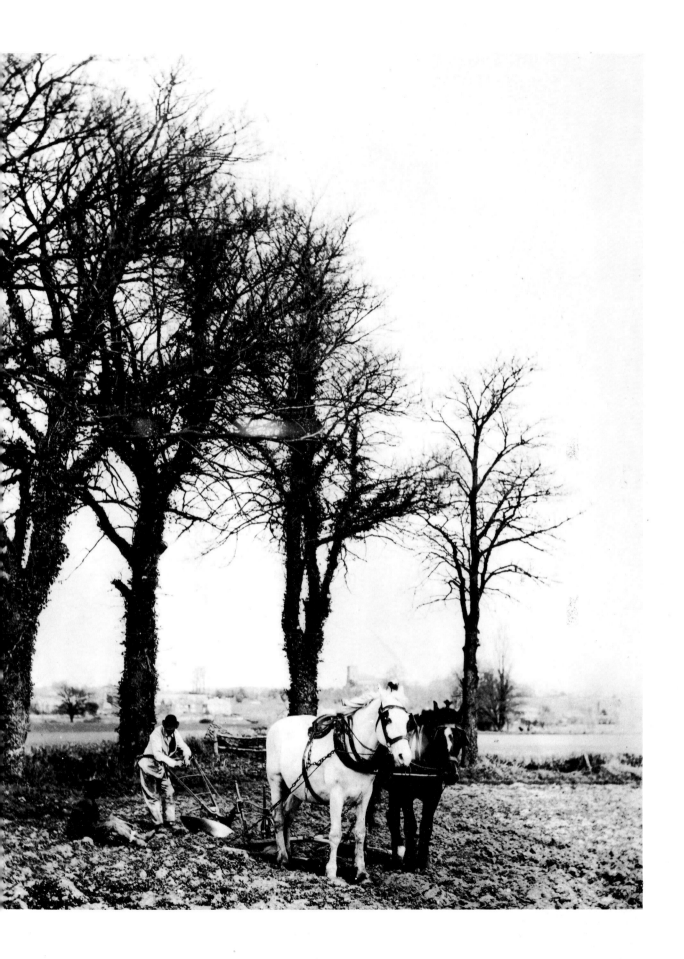

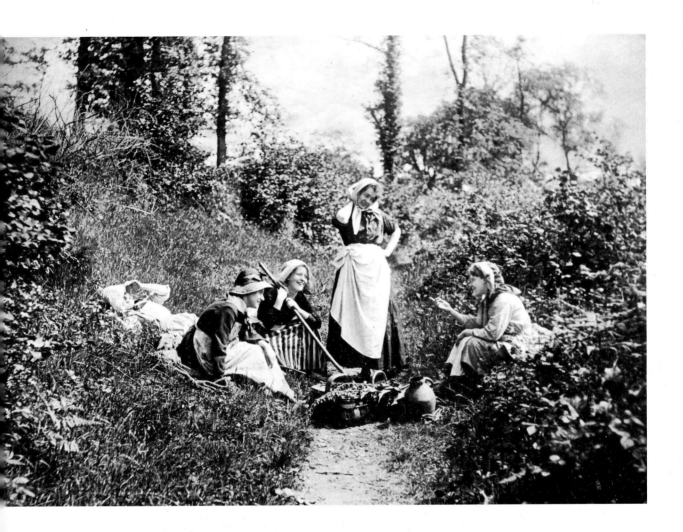

Left 'The Gilly-flower', a combination print from two negatives, by H. P. Robinson, c1880

Top 'A Merry Tale', by Henry Peach Robinson, c1883

Above 'When Day's Work is Done', a combination print from six negatives, by Henry Peach Robinson, 1877

Above left '*Harlech Castle*', *photogravure print by George Davison, c1907*

Left '*A Stiff Pull*', *photogravure print by P. H. Emerson, c1890*

Above '*St Agnes*', *by Mrs Julia Margaret Cameron, c1868*

Right '*Mrs Grosvenor Thomas*', *photogravure print by J. Craig Annan, 1897*

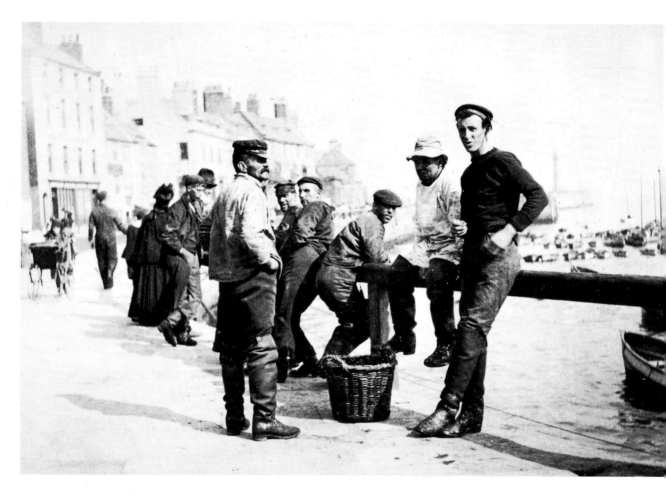

Top *Whitby fisherfolk, by Frank M. Sutcliffe, c1900*

Above '*Broad Street Railway Station', by Eustace Calland, 1897*

Right '*On the Banks of the Wey', photogravure print by A. Horsley Hinton, c1897*

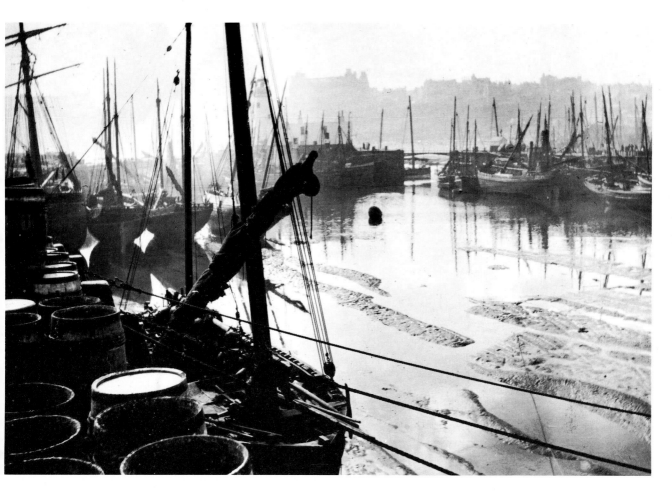

Top *Whitby harbour, by Frank M. Sutcliffe, c1900*

Above '*Watching for the Return*', *photogravure print by Alfred Stieglitz, 1894*

Top '*Mother and Child*' *by Edward Steichen, c1906*

Above '*Sewing*', *photogravure print by Gertrude Kasebier,*
c1899

Centre '*St Paul's from Ludgate Circus*', *photogravure print*
by Alvin Langdon Coburn, c1901

Far right '*The Dream*', *by Annie W. Brigman, c1906*

13 'You press the button...'

For the photographic historian the era of popular photography which began with the introduction of the first Kodak camera in 1888 is that of the anonymous photograph. The work of the photographers discussed in previous pages was often clearly identified and published in books, exhibitions, portfolios and the like, often in large editions. Even the unpretentious carte de visite photographer is usually readily identified by the trade card on which the picture is mounted. On the other hand the snapshot is usually anonymous and it is rare for more than one copy to exist. Both sitter and photographer may be no longer identifiable. Yet, without being works of photographic art, these primitive pictures are of great historic significance, showing the ordinary man and woman, not in their Sunday best in the portraitist's studio, but in their street or working clothes, relaxing on the beach or about their business. Through them we have a detailed picture of everyday life of a kind never previously available. Some, by happy accident or careful composition, are pictures of real merit.

Photography is the richer for them.

The Blériot monoplane, Hendon 1911

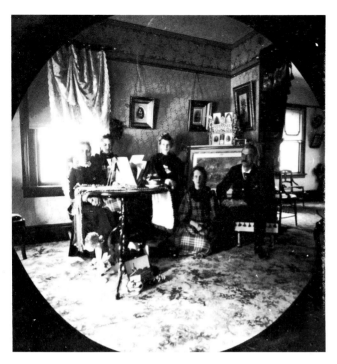

Top left *An American family at home, c1892*

Top right *The pony trap, c1892*

Above left *Street urchins, c1890*

Above right *The sisters, c1892*

Right *The game of cards, c1902*

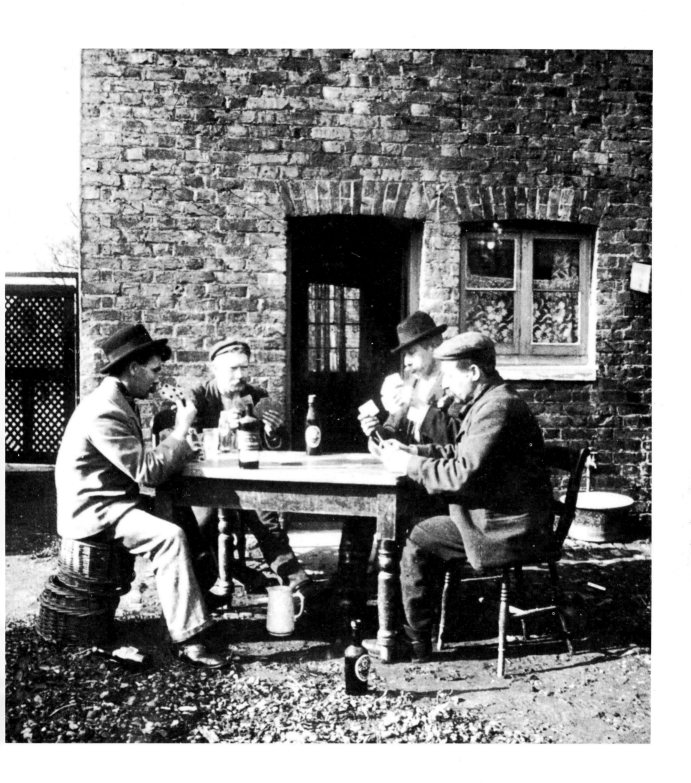

Top *The great balloon race, 1908*
Above *Siesta, c1908*
Right *Three generations, c1906*

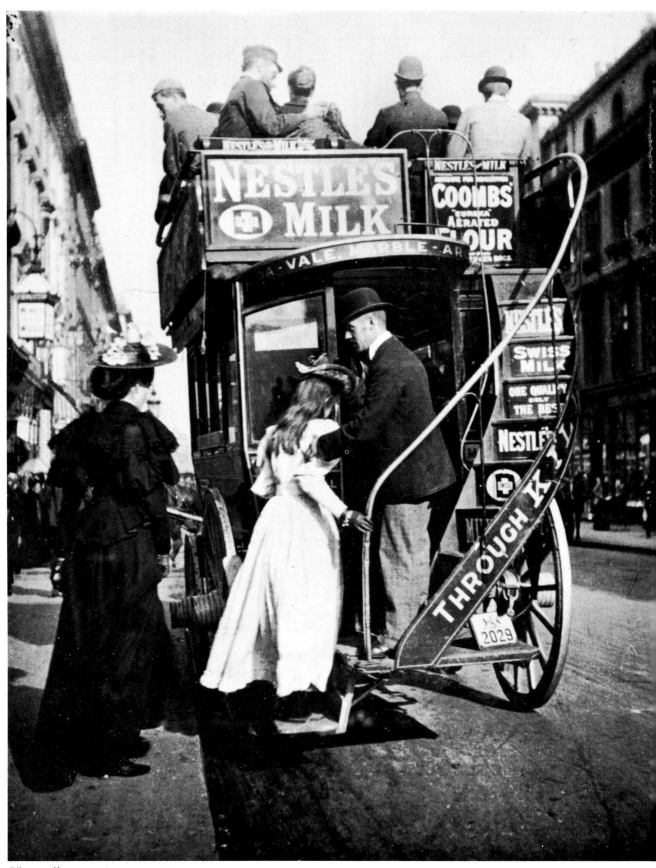

The omnibus, c1900

On the beach, c1910

Top left *Trafalgar Square, c1905*

Top right *A glass of port, c1900*

Above left *The invalid, c1900*

Above right *The nursemaid and the bobby, c1898*

Top *Peeling apples, c1908*
Above *A game of marbles, c1902*

Left *The wave, c1908*
Below left *The temple, c1910*
Below '*Where shall we go?*', *c1906*

Glossary

Actinometer A device for measuring the amount of light available for photography. It employed a piece of light-sensitive paper which darkened on exposure to light. The time taken for the paper to darken to match a standard tint was measured and this information, applied to a calculator, enabled the photographer to work out the necessary exposure.

Albumen An organic material found in both plants and animals. It occurs in a very pure form as white of egg. It was used in several early photographic processes, notably the albumen plate process of Niepce de Saint-Victor and Blanquart-Evrard's albumen paper process.

Albumen paper Introduced by Blanquart-Evrard in 1850, as an improvement on the Calotype printing paper. By coating paper with eggwhite before sensitizing, a smoother, slightly lustrous surface was produced and the paper was capable of recording finer detail. Albumen paper remained in almost universal use until the 1890s.

Amalgam A mixture of two or more metals; in photography, mercury amalgamated with silver formed the Daguerreotype image.

Ambrotype A trade-name applied to the collodion positive process, especially in America.

Ammonium chloride A compound of ammonia and chlorine, used in the preparation of albumen paper.

Aperture In photography, the light-gathering capacity of the lens, which is usually expressed as an f/ number, obtained by dividing the diameter of the lens opening into the focal length (q.v.).

Aquatint engraving A process in which the metal printing plate was sprinkled with resin particles before the design was made and the plate etched. The method gave greater subtlety and depth of tone, compared with conventional engraving.

Bitumen of Judea An asphalt found in Syria, Trinidad and elsewhere. A varnish made by dissolving it in a suitable solvent, when coated and dried, hardens when exposed to light. It was used by Niepce to make the first permanent photographic images. It was later employed in several photomechanical printing processes to prepare printing plates or stones.

Bromine One of the family of halogen elements, with chlorine, iodine and fluorine. Used directly in the improved Daguerreotype process, but in later processes employed as a compound with other elements in the preparation of light-sensitive silver bromide.

Cabinet A popular size of mounted portrait photograph, about four inches by five and a half inches, introduced in 1866.

Cadmium bromide A compound of cadmium and bromine, used from 1871 by Dr Maddox in the preparation of the first successful gelatin-silver bromide emulsion.

Calotype The name given by Talbot to his improved process of 1840, in which, by a process of development a latent image was made visible on the sensitized paper. The word comes from a Greek root meaning beautiful picture.

Camera lucida Introduced by W. H. Wollaston in 1806. It incorporated a small prism supported over drawing paper. On looking through the prism, an image of the subject was seen superimposed on the paper. By following the image with a pencil, a sketch of the scene could be produced. Lack of success with this instrument led Talbot to begin his experiments in photography.

Camera obscura Literally, a dark room. The name was first given to a darkened room in which an image of the world outside was formed by a pinhole or lens. It evolved into a portable form in which a box carried a lens, mirror and ground-glass screen, from which the image could be traced or copied. This device, originally an artist's aid, developed into the photographic camera.

Carte de visite A popular size of mounted photograph introduced in the 1850s. Measuring about four inches by two and a half inches, cartes remained popular until the early years of this century.

Cartridge film Early description of the paper-backed rollfilm on a spool. It was so named for its similarity in shape to a shotgun cartridge, and its ease of loading into the camera.

Celluloid A material made from cellulose nitrate, with additives to improve its characteristics. Invented

by Parkes, and called by him 'Parkesine', in 1861. Highly inflammable, it is no longer used in photography, being replaced by transparent films made from non-inflammable cellulose triacetate or polyester plastics.

Chronophotography The use of multiple cameras exposing in sequence, or of a single camera recording series of images in succession, at short and accurately controlled intervals. The techniques of chronophotography gave rise to cinematography in the 1890s.

Collodion A solution of guncotton in ether, or alcohol and ether. The guncotton was formed by dissolving cottonwool in a mixture of nitric and sulphuric acids. Collodion was discovered by an American, Maynard, in 1847. First used for medical purposes, it was employed by Scott Archer as the basis for the highly successful wet-collodion process, the description of which was published in 1851.

Collodion positive A whitened wet-collodion negative, which when set against a dark background appears as a positive image. It was popular in the 1850s and 1860s; in America it was widely known under the trade name 'Ambrotype'.

Combination printing The technique of printing from several negatives onto a single piece of photographic paper. The technique was popular in the 1850s and 1860s; notable users of the method were O. G. Rejlander and H. P. Robinson.

Concave mirror One with an inwardly curving surface, capable of forming an image on a surface placed on the same side of the mirror as the subject.

Convex lens A lens with one or both surfaces outwardly curving, capable of forming an image on a surface placed on the opposite side of the lens to the subject.

Daguerreotype The name given to the process introduced in 1839 by L. J. M. Daguerre, in which an image was formed upon the silvered surface of a copper plate, after sensitizing with iodine vapour. The image was developed with mercury vapour. It went out of general use in Europe in the mid 1850s, but persisted for rather longer in America.

Detective camera The name given to early hand-held cameras, frequently disguised as parcels or books or worn concealed under clothing. They were popular between 1885 and 1900.

Development In photography, a process whereby an invisible or latent image is made visible by chemical treatment. In the Daguerreotype process, mercury vapour was used to intensify the faint image, by

amalgamation with the image silver. In later processes a variety of compounds were used, including gallic acid, pyrogallol and iron salts.

Diorama A spectacular theatrical entertainment invented by Daguerre. Huge translucent paintings were given animation and dramatic effect by changing lighting, movement and so on. A popular entertainment during the first part of the 19th century.

Dope Name given to the solution of celluloid used in the manufacture of transparent film.

Emulsion In photography, the term describes a suspension of light-sensitive silver salts in a suitable medium, usually gelatin.

Engraving A printing process in which designs are cut in metal, wood or stone. After inking, the design can be transferred to paper. The name also describes the image so produced.

Etching A printing process in which printing plates are prepared by attacking the surface with a corrosive liquid, except where protected by a suitable material forming the design. The name also describes the picture so produced.

Ether A highly volatile and inflammable liquid, prepared by distillation from alcohol treated with sulphuric acid. Used as a solvent for guncotton in the preparation of collodion.

Ferrotype A trade-name for the collodion positive process applied to black or brown enamelled tinplate sheets. Becoming popular around 1860, it was used by itinerant 'while you wait' photographers, surviving almost to this day. Also known as 'tintype', especially in America.

Fixing In photography, the process of removing the unused light-sensitive salts from exposed and developed photographic materials, in order to make the image permanent. Early photographs were fixed by treatment with strong salt solution, converting the sensitive salts to a much less sensitive compound. Sir John Herschel suggested the use of sodium thiosulphate (hyposulphite of soda, in the older chemical nomenclature) in 1839. Thiosulphates have remained the standard fixing agents ever since.

Focal length The distance a lens must be placed from a surface to form a clear image of an object at infinite distance.

Focal plane shutter A shutter acting immediately before the plate or film. In older cameras, usually of fabric. The focal plane shutter is capable of very brief exposures of one-thousandth of a second or less.

137

Gallic acid An organic compound produced by fermentation from powdered vegetable galls, used by Talbot and others as a developing agent for paper negatives.

Gelatin An organic material obtained from bones, skins, hooves and other animal substances. It absorbs water and melts if warmed, setting as a jelly when cooled. Used first with success as a vehicle for silver salts by Dr Maddox in 1871, and has remained the principal medium for photographic materials ever since.

Gold chloride A compound of gold and chlorine, formed by dissolving gold in aqua regia (a mixture of nitric and hydrochloric acids). Used to tone and preserve Daguerreotype images, and in toning solutions for photographic papers.

Gum bichromate A coating of gum arabic, containing a pigment, and sensitized with potassium bichromate. This renders the coating insoluble when light falls on it. Washing the exposed print with water removes the insoluble portions. By brushing or swabbing the photographer is able to exert considerable control over the appearance of the final result. It was much used by pictorial photographers at the end of the last century.

Hypo see Sodium Thiosulphate.

Instantaneous photograph One made with a sufficiently brief exposure so as to record a clear image of moving objects. Only generally practical after the introduction of the gelatin dry plate.

Iodine With chlorine, bromine and fluorine, one of the halogen elements. Used by photographers directly to form silver iodide on the silvered plate of the Daguerreotype process.

Latent image An exposure to light which is insufficient to produce a visible image on photographic material produces a latent image which can be revealed by development.

Lavender oil An oil extracted from the lavender plant, used by Niepce as a solvent for the bitumen coating in his heliographic process.

Light petroleum Also known as petroleum ether. A volatile solvent distilled from petroleum, used by Niepce as a solvent for the bitumen coating on his metal plates.

Lithography A mechanical printing process in which designs are prepared on a stone block, from which prints can be taken. Introduced at the end of the 18th century.

Matt A decorative mask, usually of brass, bound up with Daguerreotypes and collodion positives.

Mercuric Bichloride A compound of mercury and chlorine, used in the collodion positive process to whiten and strengthen the weak negative image.

Mercury A metal, liquid at room temperatures. Mercury vapour was used to develop the Daguerreotype image. The mercury amalgamated with the minute specks of metallic silver formed in the silver iodide layer by the action of light, to produce a visible image.

Microphotography The process of making photographic images of microscopic size. Often confused with photomicrography (q.v.).

Miniature paintings Portraits painted on a small scale, typically only a few inches high. Very popular in the 18th and early 19th centuries.

Negative The image formed after exposure and development. The tones of the subject are reversed, the light parts being dark in the negative, the dark light. The name was suggested by Sir John Herschel.

Nitric acid A heavy, corrosive liquid, used to dissolve silver in the preparation of silver nitrate.

Parkesine The name given to the first preparation of celluloid by its inventor Alexander Parkes.

Pellicle The name given by Richard Kennett to his dried gelatin emulsion, 1874.

Photogenic drawing The first process devised by Talbot in 1834, in which writing paper was made sensitive to light by impregnating it with silver chloride.

Photogravure A photomechanical printing process invented by Karl Klic of Vienna in 1879. A copper plate, grained with resin dust, is etched through a gelatin relief image prepared photographically. The etching is then inked and printed. The process was extensively employed by pictorial photographers at the end of the 19th century.

Photomechanical printing Printing methods in which photographic images are used directly in the preparation of ink printing plates.

Photomicrography Photography through the microscope, giving enlarged images of minute objects. Often confused with microphotography (q.v.).

Physionotrace A method for multiple printing of profile pictures. Invented by Chrétien in 1786, the

machine employed a mechanical linkage between a stylus moved over a profile cast on a glass plate and an engraving tool acting on a copper plate. The engraved plate was inked and printed in quantity.

Pinchbeck An alloy of zinc, copper and tin, used as an imitation of gold. Employed for frames and mounts for some early photographs.

Positive A print made from a photographic negative, in which the tones of the original are restored, light for light, dark for dark. The term was coined by Sir John Herschel.

Potassium iodide A compound of potassium and iodine, used in the preparation of silver iodide when sensitizing in several photographic processes.

Printing frame A glazed wooden frame in which a negative on glass or paper was held in close contact, under pressure, with printing paper, while exposed to daylight for printing.

Prism A glass block of triangular section. In passing through a prism, images become laterally reversed, as in a mirror.

Pyrogallic acid Properly called pyrogallol, it is prepared from gallic acid by sublimation. It was extensively used as a developing agent in the 19th century.

Rollholder A device, replacing the plateholder on a plate camera, containing a roll of sensitive material suitable for a number of exposures.

Salt Common salt is sodium chloride, a compound of sodium and chlorine. It was used in the sensitizing process in a number of early photographic processes, reacting with silver nitrate to form light-sensitive silver chloride. Strong solutions of salt were used by Daguerre and Talbot as fixing agents in their early experiments.

Sensitizing The process by which light-sensitive silver salts are formed on or in a suitable surface.

Sensitometry The measurement of the sensitivity or 'speed' of photographic materials. The techniques were pioneered by Hurter and Driffield in the last two decades of the 19th century.

Shutter A mechanical device placed before, in or behind the lens, which can be opened and closed for a controlled length of time, to permit exposure of the plate or film.

Silver A precious metal, most compounds of which are sensitive to light. The silver halides – silver chloride, silver bromide and silver iodide – are the compounds most frequently used in photographic materials.

Silver nitrate Formed by dissolving silver in nitric acid. Used in the sensitizing process, reacting with salts containing chlorine, bromine or iodine to form light-sensitive silver halides.

Sodium thiosulphate Originally known as Hyposulphite of soda, or Hypo. Its property of dissolving salts of silver was first noticed by Sir John Herschel in 1819; in 1839 he suggested its use as a photographic fixing agent. It has remained in use ever since.

Stanhope lens A small plano-convex lens giving a highly magnified view of a transparent object placed upon the lower, flat surface. Mounted in a variety of souvenir items, they were used for viewing microphotographs.

Stereoscopic pictures Vision in depth is produced when the brain fuses the slightly dissimilar images provided by the eyes, separated by several inches. If two photographs are taken from similarly different viewpoints, and are viewed in a device permitting the left eye to see only the left-hand image and the right eye to see only the right-hand image, the result is a picture with apparent depth. Stereoscopic photography became popular at the Great Exhibition in London in 1851, the twin pictures for the stereoscope being taken in a single camera moved between exposures; later, twin lens cameras recording the two images simultaneously permitted the stereoscopic recording of action scenes.

Stripping film A support, usually paper, bearing a sensitized layer which after exposure and development could be removed from the paper base and transferred to a more transparent support. Except for special applications, it became obsolete after the introduction of transparent celluloid film.

Thermoplastic moulding A technique for production of decorative or functional articles, in which a suitable material, soft when heated, is pressed into a mould or die. The plastic material sets hard when cold, retaining the fine details of the design. The technique was first used on a large scale for the production of Union cases (q.v.) in the 1850s.

Tintype Alternative name for ferrotype (q.v.).

Toning A process by which the tone or image colour of a photograph may be changed by chemical treatment. In addition to changing the image colour, many toning processes make the image more permanent.

Union case A decorative case for Daguerreotypes or collodion positives, made by an early process of

thermoplastic moulding. They were of American origin, and popular in the 1850s.

Viewfinder An optical device, often in the form of a miniature camera obscura, attached to the hand-held camera to enable it to be accurately aimed by the photographer.

Waxed paper process A variant of the Calotype process in which the paper was treated with wax before sensitizing. The paper was thus made more transparent for printing and the keeping properties of the unexposed paper were improved. Calotype negatives were usually waxed *after* development to improve their transparency.

Bibliography

There are many books of varying quality on the history of photography in general and on special aspects. The following is a selection from those published in Great Britain and the USA in recent years:

General books on photographic history:
Beaton, Sir Cecil, and Buckland, Gail, *The Magic Image: the genius of photography from 1839 to the present day*, Weidenfeld & Nicolson, London, 1975
Buckland, Gail, *Reality Recorded: Early Documentary Photography*, David & Charles, Newton Abbot, 1974; New York Graphic Society, Boston, 1974
Gernsheim, Helmut & Alison, *The History of Photography*, Thames & Hudson, London, 1969; Aperture, Millerton, NY, 1973
Hillier, Bevis, *Victorian Studio Photographs*, Ash & Grant, London, 1976; David Godine, Boston, 1976
Jenkins, Reese V., *Images and Enterprise: Technology and the American Photographic Industry*, Johns Hopkins University Press, Baltimore, 1975
Newhall, Beaumont, *The History of Photography*, Museum of Modern Art, New York, and New York Graphic Society, Greenwich, Conn., 1972; Secker & Warburg, London, 1973
Pollack, Peter, *The Picture History of Photography*, Harry N. Abrams, New York, 1969
Scharf, Aaron, *Pioneers of Photography*, British Broadcasting Corporation, London, 1975

Books for collectors:
Castle, Peter, *Collecting and Valuing Old Photographs*, Garnstone Press, London, 1973
Howarth-Loomes, B. E. C., *Victorian Photography: a Collector's Guide*, Ward Lock, London, 1975; St Martin's Press, New York, 1975
Mathews, Oliver, *Early Photographs and Early Photographers*, Reedminster Publications, London, 1973; Pitman, New York, 1973
Welling, William, *Collector's Guide to Nineteenth Century Photographs*, Macmillan, New York, 1976

Books dealing with apparatus and special processes:
Auer, Michel, *Illustrated History of the Camera*, Argus Press, King's Langley, 1975; New York Graphic Society, Boston, 1975
Holmes, Edward, *An Age of Cameras*, Fountain Press, King's Langley, 1974; Morgan & Morgan, Dobbs Ferry, NY, 1974
Lothrop, Eaton S., Jr, *A Century of Cameras*, Morgan & Morgan, Dobbs Ferry, NY, 1973
Thomas, Dr D. B., *The First Negatives*, Her Majesty's Stationery Office, London, 1965
Thomas, Dr D. B., *The Science Museum Photography Collection*, Her Majesty's Stationery Office, London, 1969
Wakeman, Geoffrey, *Victorian Book Illustration*, David & Charles, Newton Abbot, 1973; Gale, Detroit, 1973

Books dealing with individual photographers:
Coe, Brian W., *George Eastman and the Early Photographers*, Priory Press, London, 1973
Doty, Robert, *Photo-Secession: Photography as a Fine Art*, George Eastman House, Rochester, NY, 1960
Ford, Colin, *The Cameron Collection*, Van Nostrand Reinhold, New York & Wokingham, 1975
Ford, Colin, and Strong, Dr Roy, *An Early Victorian Album – The Hill-Adamson Collection*, Jonathan Cape, London, 1974; Alfred A. Knopf, New York, 1976
Hiley, Michael, *Frank Sutcliffe*, Gordon Fraser, London, 1974; David Godine, Boston, 1975
MacDonnell, Kevin, *Eadweard Muybridge: The Man Who Invented the Moving Picture*, Weidenfeld & Nicolson, London, 1972; Little, Brown, Boston, 1972
Millward, Michael, and Coe, Brian W., *Victorian Townscape, the Work of Samuel Smith*, Ward Lock, London, 1974
Turner, Peter, and Wood, Richard, *P. H. Emerson*, Gordon Fraser, London, 1974; David Godine, Boston, 1975

Index